Historic England

# Drawing for Understanding

Creating Interpretive Drawings of Historic Buildings

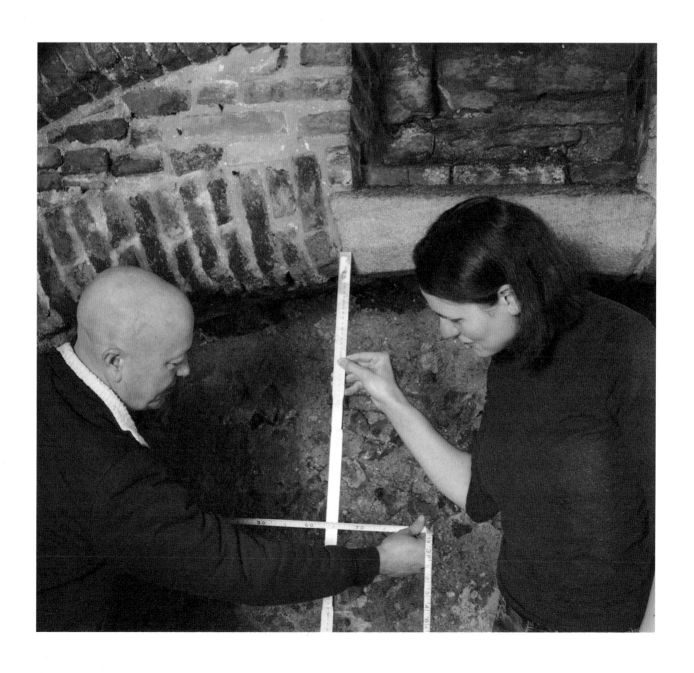

# Summary

This Historic England guidance describes a method of recording historic buildings for the purpose of historical understanding using analytical site drawing and measuring by hand. The techniques described here have a long tradition of being used to aid understanding by observation and close contact with building fabric. They can be used by all involved in making records of buildings of all types and ages, but are particularly useful for vernacular buildings and architectural details which are crucial to the history of a building or site.

Record drawings are best used alongside other recording techniques such as written reports and photography (as described in Understanding Historic Buildings (https://historicengland.org.uk/images-books/publications/understanding-historic-buildings/) or to supplement digital survey data (see also Traversing the Past: The total station theodolite in archaeological landscape survey (https://historicengland.org.uk/images-books/publications/traversingthepast/). They can also be used as a basis for illustrations that disseminate understanding to wider audiences.

This guidance has been prepared by Allan T Adams.

First published by Historic England July 2016.
All images © Historic England.

HistoricEngland.org.uk/images-books/publications/drawing-for-understanding/

**Front cover**
A folding rod and tape measure being used during the
survey of an early medieval undercroft in Ely.

# Contents

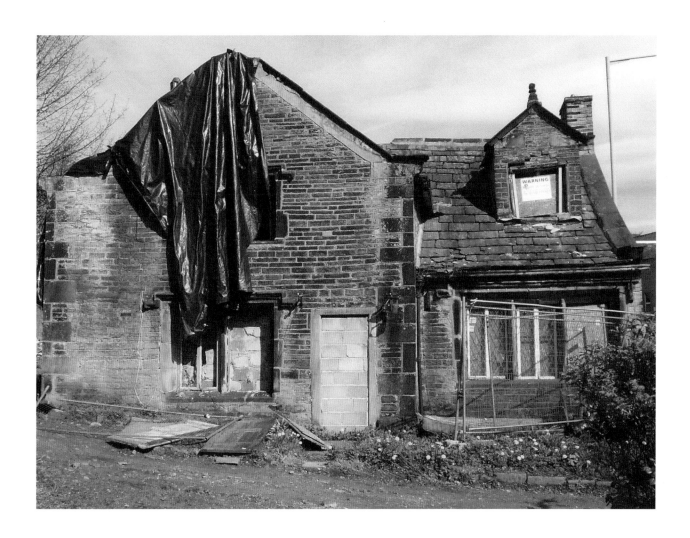

**Image**
Exterior view of Old Manor House, Manningham,
Bradford. Featured in Case Study 4.

# 1 Introduction

Historic buildings are a conspicuous feature of our surroundings, constituting a rich store of information about the past: how the buildings were made, how they were used, and therefore, how they have influenced their surroundings. Unlocking that store is reliant on concepts, skills and techniques from a range of disciplines, including historical research, archaeology, architecture and surveying. A fundamental activity is the collection, analysis and interpretation of evidence embodied in the fabric of standing buildings. The understanding that results from this activity underpins the appreciation and care of individual buildings and of the historic environment as a whole. The essential units of information, whether they form studies of single buildings or are included in works that bring together many such studies, are the records of individual buildings and complexes; a key component of such records is the drawings.

## 1.1 Background: why draw historic buildings?

Drawings are an efficient way of conveying the evidence on which an interpretation is based and are a powerful analytical tool in their own right (Figure 1). The act of drawing entails a degree of interpretation, or selection, of what is significant, thus the person making the drawing needs to be concise about what to draw and understand as fully as possible what he or she is looking at.

Drawing on site can assist with orientation and help ensure a building is recorded fully. More finished drawings greatly assist readers in understanding the building or site. Drawings, like photographs, can also communicate to a wider audience without the need for the audience to understand fully the written language of architectural history.

The aim of this guidance is to introduce the various types of interpretative illustration that will enhance the understanding of historic buildings and cost effective methods of making them. Such illustrations can be used:

- alongside written analytical and descriptive accounts in reports on individual buildings

- to provide an additional level of information about key building features also recorded by photography

- to provide more readily understandable contextual information for written accounts of buildings

- as research tools, especially when the drawings include the evidence based reconstruction of elements that have been altered or removed

- as publication or exhibition drawings

- to form the basis for more complex architectural illustrations, such as cutaway views.

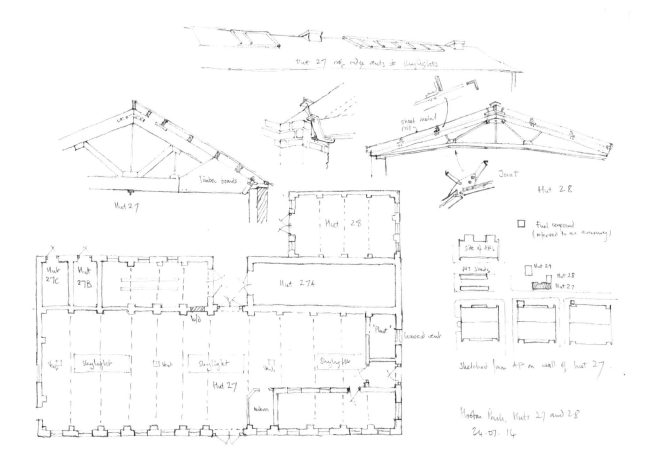

**Figure 1**
Site sketch notes of buildings at Hooton Park airfield near Ellesmere Port, Cheshire. They provided a useful extra resource for the survey. No further work was undertaken on them. See RRS 76-2014.

Drawings are seldom used alone but form an integral part of a larger whole. This usually includes a written account and photography, as well as drawings, to capture the development of a building, a complex of buildings or other sites over time.

## 1.2    Drawing methods

Drawings derived from accurate measured survey facilitate more objective interpretations because the underlying data are measurable. Scale drawings also provide a means of comparing like for like or accentuating differences when working on thematic studies. There are a number of ways of undertaking drawn surveys. These include:

- traditional hand-drawn and hand-measured methods

- total-station surveys employing theodolite and electronic distance-measuring equipment

- photogrammetry

- rectified photography

- 3-dimensional (3D) laser scanning.

Combinations of these techniques can be used (Figure 2). There are also various methods of completing the drawings to deliver the finished survey to its desired audience, ranging from pencil and pen drawings to computer-aided design (CAD) models and scaled photographs. Different types

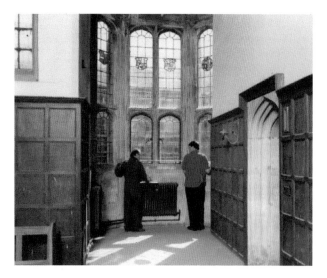

**Figure 2**
Measuring by hand involves intimate contact with the building and can greatly enhance the information gleaned from a site. It is particularly effective when combined with TST surveying.

or a combination of several techniques, hand-drawn and measured survey drawings offer the maximum engagement with the subject. Hand-drawn illustration techniques are also the most flexible and widely applicable, delivering the requisite level of detail and type of end-result for many projects.

A drawn record is usually combined with a written account, which often includes the results of documentary research. These are typically records on individual buildings or complexes. Drawings might also be needed to illustrate thematic studies about groups of buildings or areas. Various types of output may be required, ranging from very small web-based images to exhibition panels. Record drawings can be adapted to perform these other functions but it is worth bearing in mind that good illustration does not always stem directly from all-inclusive, detailed record drawings; some simplification of detail is often desirable.

of survey are required for the different uses; major restoration projects and condition monitoring, for example, are occasions when minutely accurate computer-aided recording is necessary. These techniques require a high level of training and technical skill.

Although illustrations can be made by traditional methods, using computer software

Background research will greatly enhance any drawn record. Prior reading about the subject being recorded and looking at other published examples can help direct inquiry and provide pointers about what to look for while on site. It will also help to shape the form that the finished drawn record will take although it is important to avoid preconceptions of what will be found.

| | Hand survey | Total station | Photogrammetry | Laser scan |
|---|---|---|---|---|
| Plans-simple site | ✓✓✓ | ✓✓✓ | ✓ | ✓✓✓ |
| Plans-complex site | ✓✓ | ✓✓✓ | | ✓✓✓ |
| Sections | ✓✓ | ✓✓ | | ✓✓✓ |
| Elevations | ✓✓ | ✓✓ | ✓✓✓ | ✓✓ |
| Moulded details | ✓✓✓ | ✓ | ✓ | ✓ |
| Timber frame joints | ✓✓✓ | ✓ | ✓ | |
| Inaccessible | | ✓✓✓ | ✓✓✓ | ✓✓✓ |

**Table 1**
A comparison of different surveying methods used to generate data for drawings. The most effective method in each case is shown with three ticks, with no tick showing the method to be unsuitable.

## 1.3 Methodology statement

Whatever method is used to gather data on site and generate the finished drawings will have advantages and disadvantages. The relative suitability of various methods of gathering data is compared in Table 1. 'Inaccessible' refers to elements that are visible but difficult to gain access to physically, for example the outer walls of moated sites or external features that can be seen but not reached without complicated access equipment.

The type of survey and resultant drawings should therefore be indicated in a brief statement in the methodology section of an accompanying report. This should make clear the level of detail and accuracy used for the drawn component of the record.

## 1.4 Historical background

Taking measurements by hand to produce measured drawings and illustrations, including most of the commonly used forms of drawing, has a pedigree stretching back many centuries, for example the work of Andrea Palladio in the 16th century, who produced measured drawings of Roman architectural remains published in 1570 as *Quattro Libri dell' Architettura (The Four Books of Architecture)*. British antiquarians of the 17th century, such as William Dugdale, employed artists to illustrate their studies, the latter notably employing Wenceslaus Hollar to create multiple views of, for example, St Paul's Cathedral and bird's-eye views of other important monuments, for example Windsor Castle. The 18th century antiquarian Reverend William Stukeley considered drawing as essential for the study of history and science, often producing his own illustrations. Nineteenth-century artists and architects, such as Henry Oldfield and John Buckler, produced carefully observed drawings, the latter often adding dimensions to his drawings, as might be done today on dimensioned sketches. The techniques for hand survey discussed below are descended from this approach. They have been developed over many years by the Royal

Commission on the Historical Monuments of England (RCHME), and the Royal Commissions for Scotland and Wales, to form the basis of the system practiced today by the recording teams of Historic England and underpinning the current, widely used, *Understanding Historic Buildings: A Guide to Good Practice* (Lane 2016).

Reconstruction drawings can also be valuable analytical tools because the creation of such drawings often requires the reassessment of data in order to be visually convincing (Figure 3). Their value in building recording and interpretation stems from the work of artists such as Alan Sorrel and Terry Ball, whose reconstructions for the Ministry of Works and its successors not only helped broaden public interest in the past but also influenced interpretations of the sites they were illustrating. Peter Smith used reconstruction and cutaway drawings in *Houses of the Welsh*

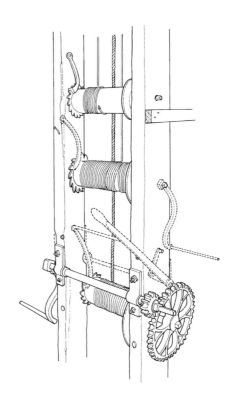

**Figure 3**
The written description of the hoist mechanism in the deer slaughterhouse in Levens Park, Levens, Cumbria was rewritten after the reconstruction drawing established how the missing parts, shown here in broken lines, may have worked.

*Countryside: A Study in Historical Geography* (Smith 1975) as an integral part of analysing the buildings. It is important to be clear about what can be verified as fact and not rely on supposition; however, such work has had a major impact on broadening public awareness of the historic environment as well as widening the range of tools available to the building recorder.

## 1.5 The language of architectural drawings

### Architectural drawing conventions

Architectural drawings are a means of conveying a sense of three-dimensional objects in two dimensions. This abstraction has led to the development of a specialised language, or drawing conventions. The main drawing conventions used to describe architecture are the orthographic projections of plan, section and elevation, parallel projections (axonometric and isometric) and perspectives. Despite advances in computer technology that make it possible to see virtual models in three dimensions, the versatility of two-dimensional(2D) drawings for conveying information in a concise way has ensured that it is still a common means of portraying this information.

### Plans

Plans are diagrams of buildings projected on a flat surface or as a horizontal section through the building. They are probably the most common form of architectural drawing and are one of the most informative. A plan conveys an impression of the size and layout, and the shape and circulation, of a building that other forms of drawing seldom do so well.

### Sections

A section, either cross or longitudinal, is a drawing representing a building as it would appear if cut through on a plane at right angles to the line of sight. This illustrates the vertical relationships within the building, something plans do not do so well. Sectional elevations are sections that also show detail beyond the cut line and should be used when it is helpful to show the relationships of building parts in more depth.

### Elevations

An elevation is a directly frontal view made in projection on a vertical plane. The information that is shown can often be equally well shown on a photograph but elevations have the advantage of being true to scale. They can also be used to highlight detail that can be difficult to see, for example a stone rubble wall, or when many later alterations have made the evidence difficult to extract.

### Axonometric and isometric projections

Parallel projections are accurate outputs showing both plan and volume in a single view by adding the height measurements. Axonometric views allow the plan to be drawn to true shape and tilted 45 degrees to the horizontal plane so that the height can be drawn to the same scale; other angles can be employed with similar results. In isometric projections the horizontals are drawn at 30 and 60 degrees.

### Perspectives

Of all architectural drawings, perspectives are probably the most easily understood by people not familiar with other conventional drawing projections. They are the most difficult type of drawing to execute and have the disadvantage of not being to scale but they can give a much better sense of space.

### Specialised drawing conventions for depicting historic buildings

The drawing conventions described above apply to all forms of architectural drawing but are adapted for different purposes. Drawings explaining the development of a building, for example, will require different features to be emphasised compared with a drawing that is being used to sell a house. This is done by using specific symbols, developed over many years, to depict the detail and impart the information of the historic buildings (see Appendix).

The following sections describe how to make use of drawing conventions to support written accounts of various types and lead to an enhanced understanding of historic buildings.

# Case Study 1

## Low Park, Alston Moor, Alston, Cumbria

Site sketches were used as base drawings for a survey that provided measured drawings to be used in turn as the basis for a number of different illustration types.

### Introduction

The North Pennines Miner Farmer Project was a wide-ranging multi-disciplinary study of the town and surrounding upland area of Alston, Cumbria. The architectural component of the study became the basis of a book on the development of the buildings (*Alston Moor, Cumbria: Buildings in a North Pennines Landscape* (Jessop *et al,* 2013) . A common type of building in the area is a distinctive form of farmhouse, with urban derivatives in the town itself, known throughout the border areas of England and Scotland as a 'bastle'. A number of detailed surveys were made of a sample of these buildings to provide illustrations for the book and planned reports on individual buildings.

Low Park, despite having had its original floor removed and the roof altered, has many original features that make it a good representative of a bastle. It probably dates from the mid-17th century, with entrances to the ground-floor cattle accommodation and first-floor house in the gable wall. This wall also retains evidence of a lightweight timber and plaster firehood capped by a stone chimney, all carried on stone corbels that remain *in situ*. It was added to at both ends over the years and had an attic storey added, the original roof

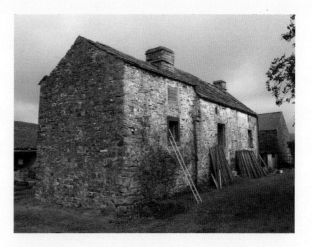

**Figure CS1.1**
The exterior of Low Park, the original bastle house is the central block.

trusses probably being reused. One end was demolished and replaced with a cattle shed in the mid-20th century. At the same time the original floor of the building was removed and new fittings introduced to meet modern cattle housing regulations. (Figure CS1.1)

## Survey method

The survey of Low Park was undertaken by two people: the illustrator and the author of the planned report and book. Working closely together they were able to discover the detailed evidence that identified the significant alterations to the building; this made the report, record drawings and illustrations more accurate and helped identify similar features, less well preserved, in other buildings. Usually ideas for possible viewpoints for book illustrations are considered during fieldwork but on this occasion this was deferred until other buildings had been surveyed. A full set of record drawings was therefore sketched and measured by hand, comprising:

- two floor plans,

- an elevation of the front of the building

- a long section

- a cross section

- two additional sections showing the main roof trusses.

These drawings incorporated a reconstruction of the part of the building added onto one end and then replaced by the cowshed, based on evidence within the building, a photograph belonging to the owner and map evidence. (Figures CS1.2 and 3)

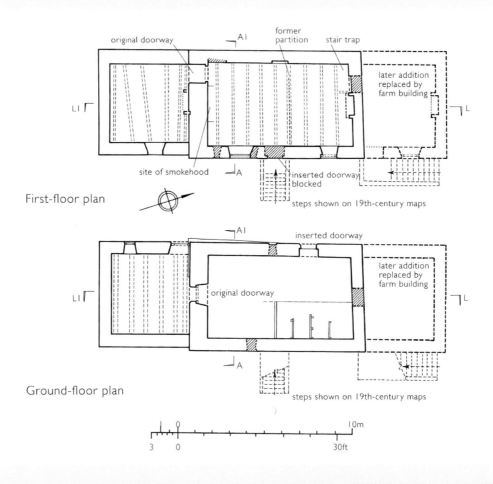

First-floor plan

Ground-floor plan

### Figure CS1.2
The completed record plans. Map evidence and a photograph belonging to the owner was used to reconstruct the part of the building replaced by a modern cattle shed at the north end.

## The illustrations

The completed record drawings, drafted in pencil and finished in pen and ink, provided the material for book illustrations. The building provided an illustrated exemplar of an unaltered bastle in use. Several sketches of different views were made to establish the viewpoint that would include as many typical features as possible. (Figure CS1.4) The view selected was drawn using pencil on tracing paper over a perspective grid, bearing in mind the need to appeal to as wide an audience as possible. Additional research was done to work out how the surviving corbels might have

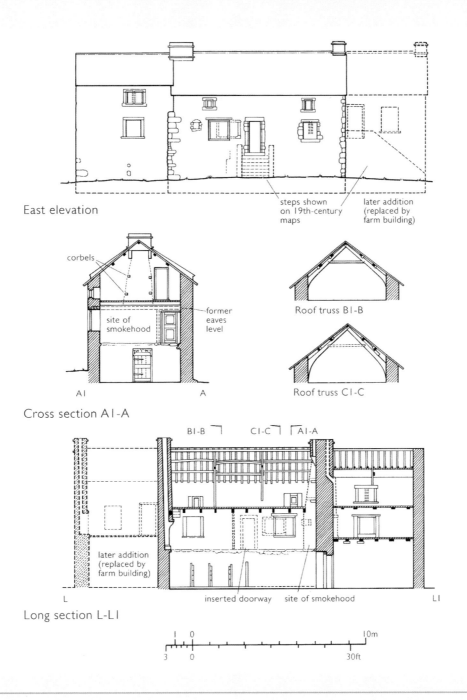

East elevation

steps shown on 19th-century maps

later addition (replaced by farm building)

corbels

site of smokehood

former eaves level

Roof truss B1-B

Roof truss C1-C

A1      A

Cross section A1-A

B1-B    C1-C   A1-A

later addition (replaced by farm building)

L       inserted doorway    site of smokehood       L1

Long section L-L1

**Figure CS1.3**
The completed record sections and elevation. These drawings, along with the plans and site photographs, provided reference material for a number of reconstruction drawings.

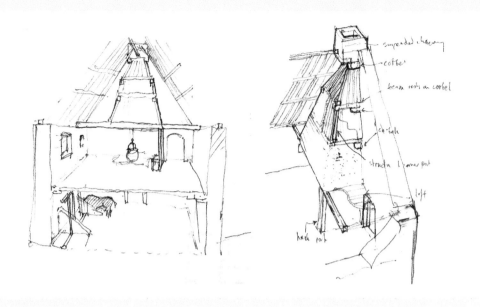

**Figure CS1.4**
The initial drafts of the cutaway reconstruction drawing. The drawing on the right concentrates on the evidence for the original timber and plaster chimney.

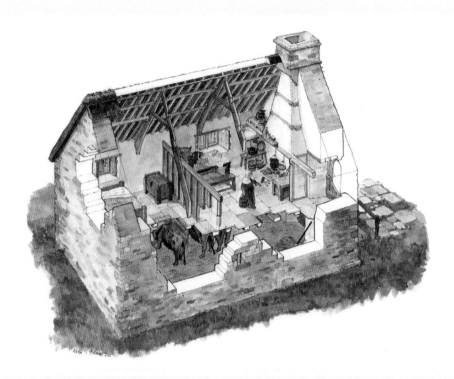

**Figure CS1.5**
The cutaway reconstruction view is a perspective drawing, in pencil and watercolour. The period furniture, people and livestock is carefully researched to recreate how the building might have looked when new in about 1650. See Jessop *et al*, 2013 *Alston Moor, Cumbria: Buildings in a North Pennines Landscape*.

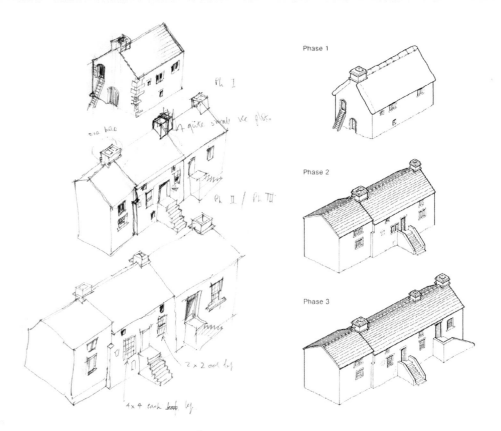

**Figure CS1.6**
A series of development drawings was also created from the record drawings, showing how Low park probably grew by having extensions added at both ends. On the left are the initial sketches, on the right the finished drawings. See Jessop *et al*, 2013 *Alston Moor, Cumbria: Buildings in a North Pennines Landscape*.

supported the missing parts of the firehood, as well as research into period furniture and livestock breeds. When the draft had been approved by the book author it was transferred onto watercolour paper by tracing the main outlines on a light box. After further drawing work, to strengthen line weights and refine details in the drawing, it was completed with watercolours. (Figure CS1.5). Sketches of the development of several bastles were made, including Low Park, which led to some being used as additional illustrations in the book. These were finished as simple outline isometric drawings, clearly showing how the structures were extended by building onto the end gable walls (Figure CS1.6).

## Conclusion
Hand-drawn and measured survey was the most appropriate method for carrying out a small number of surveys of the bastle houses of Alston Moor. It allowed detailed analytical fieldwork, closely observing and carefully measuring the selected buildings that proved to be of value for making both record drawings and illustrations. The work resulted in a number of illustrations that clearly explain how the buildings were used to support a way of life that has all but disappeared in recent times and record drawings that should help the future management of surviving examples of the bastle house.

# 2 Fieldwork: Site Sketching and Hand Measuring

## 2.1 Equipment for site sketching

All field recorders will have their own views about the equipment they prefer to needed in the field. At the most basic, the equipment needs to include something to draw and write on and something to draw or write with. Experience has shown that some items are better suited to the task than others (Figure 4).

### Paper: sketchbook and drawing boards

An A4 notebook with plain paper and a rigid, hard cover is a good way of keeping site notes together. The binding should ideally allow the book to be opened flat to serve as an A3 drawing pad. The rigid cover also enables the user to wedge the book between the body and a wall in a similar way to using a board. The notebook might also serve as local datum when measuring doors, windows and mouldings.

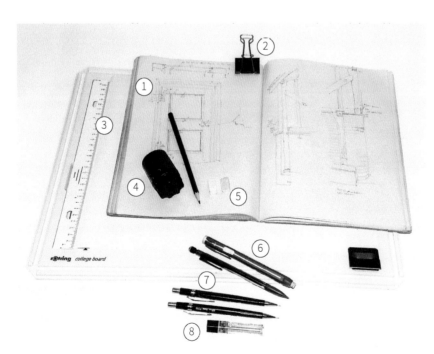

Basic fieldwork drawing equipment

1   A4-size hard-cover notebook, open flat to A3 size
2   Spring clip
3   A3 plastic drawing board with cartridge paper
4   Pencil sharpener, traditional pencil
5   Slices of plastic eraser traditional pencils
6   'Click' eraser
7   0.5mm mechanical pencils
8   Spare leads for mechanical pencils

**Figure 4**
Basic drawing equipment for fieldwork.

A3 plastic or wood drawing boards are useful if a flat drawing surface is preferred for loose sheets. They are particularly useful if drawings supplied by third parties are to be used as the basis for site work instead of drawing from scratch. Cartridge paper is good for fieldwork, being more robust than writing or copier paper. Polyester drafting film is also useful because it can be used in wet weather.

Spring clips, elastic bands and masking tape are useful for keeping paper fastened to supports or keeping notebooks open. These items can also be used to secure spirit levels and the end of tape measures to other measuring aids, and to establish artificial datum lines.

### Pencils

Graphite pencils remain the most useful way of taking notes and sketching in the field. They have the advantage of working in almost all weather conditions, as long as the drawing surface is dry or waterproof. Making a mark is immediate, without needing to dry like ink; it is also erasable.

It is good practice to carry a number of pencils in case of loss or malfunction. Mechanical pencils are perhaps best as the leads do not require sharpening and most come supplied with a small eraser. It is a good idea to check there is a good supply of spare leads before going into the field. A good average thickness for the leads is 0.5mm, and these are easy to obtain. Thinner leads snap very easily while thicker, for example 0.7mm and 0.9mm, leads will smudge more readily, making field notes and sketches difficult to read. HB leads are a good general hardness for working on paper. If drafting film is used a much harder, 4H or 6H, lead is recommended.

Wooden pencils are also useful. They will not jam, as mechanical pencils sometimes do, but they do need to be sharpened regularly. One or two coloured pencils are useful for noting measurements, particularly when there are many dimensions to write down in small spaces. For example red and blue can be used for noting length-wise and cross-wise measurements, respectively, to avoid confusion later.

### Erasers

Good-quality plastic erasers are important for adjusting sketches and correcting dimensions. Many mechanical pencils have an eraser in the end, often protected by a pull-off cover, which is useful for keeping the eraser clean. A large eraser can be sliced into smaller pieces which makes it easier when working on small areas of a drawing to avoid damaging other parts of the drawing that do not need to be altered, and it provides contingency should one eraser be lost.

## 2.2 Sketching on site

Sketching is useful for any fieldwork that aims to gain an understanding of an historic building. Such sketches need not be works of art; site sketching is simply a tool to be used to help reveal information. Like many practitioners, building recorders use sketching to make better sense of what they see. Drawing is an act of interpretation: working out how any component parts relate to each other is a process akin to taking the object apart. Each component is first separated by eye and then delineated as a series of lines to form shapes. Drawing can also be used to reverse the process and, in a virtual sense, replace missing parts. The aim of the drawings being considered here is to optimise the understanding of an historic building while also being economical to produce.

Sketches can be used with annotation to make visual notes in a very immediate way, with more clarity than a photograph alone can achieve. Such notes have the advantage of remaining with the image, while photographs are often left uncaptioned. However, it is good practice to take photographs for the record as well to compensate for inaccuracies in the sketch. (Figure 5) Site sketches should be as complete as possible: for example a plan should show all the significant rooms and section drawings all the floors in addition to the roof, even when only partially measured. This will aid understanding of the site and can be a crucial part of the record, especially if the site visit has to be cut short for any reason. Annotation should be used as necessary to make

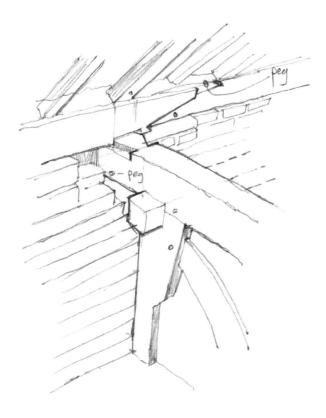

**Figure 5**
Site sketch of West Court, Shepherdswell with Coldred, Kent. The remains of an early timber frame were crucial to the understanding of the building, providing clues to its structure and date. One drawing recorded the requisite detail; in contrast, several photographs would have been needed, which even then would have had less visual clarity and would therefore have been less successful at aiding understanding.

the site sketch intelligible, even if not all the labelling will be needed in the final drawing.

Site sketches are more often used to record measurements obtained by hand-measured survey. These are important even when the survey is supported by theodolite survey. For smaller buildings it is usually necessary to start the survey from scratch. Drawings prepared for other purposes and supplied by an architects' office, for example, might also be used as the basis for collating information on site. It is during the initial analysis of the site that it will become apparent what the drawn record will need to show to underpin the understanding of the building. This will normally include as a minimum a plan, to help with horizontal orientation, and a section or

sections, to show vertical relationships. Elevations are sometimes useful when photography cannot, for a number of reasons, convey all the information necessary to make understanding clear.

## 2.3 The sketch plan

During the initial analysis of the building, as a picture of what is significant emerges, a sketch plan is drawn. Key features should be annotated, even if not all of the labelling is retained in the final drawing (Figure 6). This becomes a record of the thinking process that identifies what features are important in terms of the building's development and use. The sketch is a key component in the analysis of the building fabric and forms the basis on which measurements are placed. In general the plan is assumed to cut the walls of the building at about chest height. In this way most of the principal features in the walls, such as windows and doorways, will be shown. Sometimes, however, it is necessary to vary the plan height to show important detail above or below this line, for example high-set windows. The fact that they are set high in the wall provides important evidence about the room being surveyed. Annotation on the plan or a section drawing should be used to show their height and relationship to the floor.

Clarity is the key feature of sketch plans. Some features are better not shown in plans, for example braces in timber-framed buildings, and are better represented in other forms of drawing. Other features, such as former doorways made into windows, are clearer if explained by annotation. If the feature is critical to the interpretation it is worth drawing a detail, in the form of a partial section or elevation drawing.

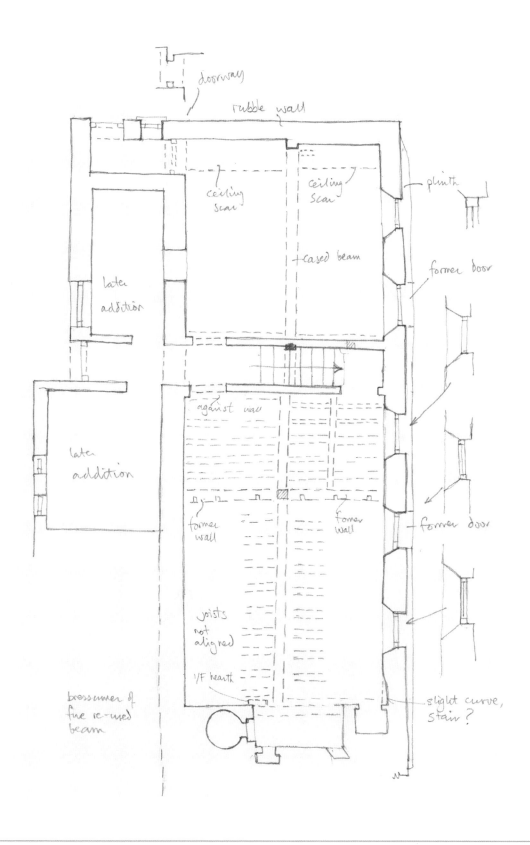

**Figure 6**
Sketch plan of 29 Lynn Road, Ely, Cambridgeshire. The sketch plan onto which measurements will be added is best done after an initial study of the building.

Photographs, including general views of the room, will assist the process. Recording for the Early Fabric in Historic Towns: Ely project (RRS 2-2016 forthcoming).

## 2.4 Sketch section drawings

Sketched section drawings or sectional elevations are also useful tools in the analysis of a building (Figures 7and 8). Sometimes such sketches serve as a prompt about what to draw for the final record. Once a sketch has been made it becomes clear what can be understood from a single drawing and hence whether additional drawings are needed, for example a second section or a sectional elevation.

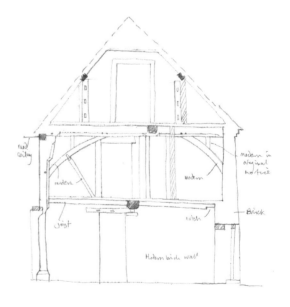

**Figure 7**
Cross-sections have the advantage of showing inone drawing (d) information that may require several photographs to show and clearly show vertical relationships in the building. Careful measuring will ensure that all the features are also correctly proportioned and positioned relative to each other. Recording for the Early Fabric in Historic Towns: Ely project (RRS 2-2016 forthcoming).

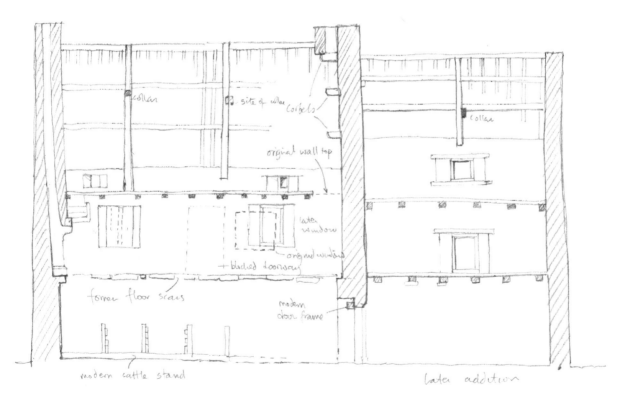

Figure 8
Long-section drawings are more informative if they also include elevation information seen beyond the line of the section (also referred to as the cutting plane). In this example, of Low Park, Alston Moor,

Cumbria, some additional information has been sketched in from the exterior, providing an extra layer of information.

### Reading the building from the sketch plan and section

The sketches in Figures 6-8 contain most of the commonly used conventions for the various materials and features found in the survey of historic buildings. The sketches also contain information about the evolution of the building. Features like straight and ragged joints in masonry point to differences in building phases. Overhead detail is important, showing the main structural timbers. The portrayal of empty mortices in these beams is suggestive of removed timber framing.

Points to bear in mind when sketching are:

■ the building should be drawn in approximately the right proportions

■ the drawing should be large enough to show the required detail clearly

■ complicated details should be sketched separately

■ variations in masonry should be recorded either as a label or in accompanying notes

■ overhead detail should be included

■ a note of the address and date of the sketch should be included as part of the title

■ the name of the recorder should be noted on any separate sheets of drawings

## 2.5 Equipment for measuring in the field

Basic field survey equipment falls into two categories: essential and desirable. Basic sketch plans and sections can be measured with the following essential items (Figures 9 and 10):

■ 5 m steel hand tape

■ 30 m measuring tape

■ 2 m folding rule (two are ideal)

■ pencils, spare leads/sharpener, erasers

■ notebook, drawing board and paper

■ board clips, spring clips

■ spirit level

■ string

■ torch

■ small camera

Desirable items that will make surveying easier and support a wider range of measuring tasks are:

■ telescopic height-measuring pole (Figure 10)

■ electronic hand-held measuring device

■ plumb line

■ nails and hammer

■ survey chalk

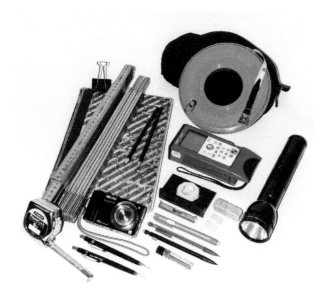

**Figure 9**
Basic measuring equipment.

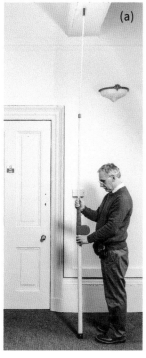 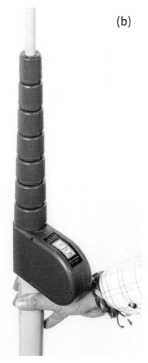

**Figure 10**
Telescopic measuring pole, extended to take a height measurement of the beam overhead (a) and a detail of the height measurement instrument (b).

Much of the measuring that is described here has been undertaken using these essential items. Two folding rules are useful as one can be used as a datum or extension of an item being measured with the other rule. One can also be held in place to extend the length beyond the 2m extent of a single rule. There are numerous occasions when innovation in using combinations of equipment is necessary.

Telescopic height-measuring poles are especially useful for taking height measurements for section drawings but can also be used as an aid for taking plan measurements of overhead details. Electronic distance-measuring devices, for example the Leica ® DISTO ™, are useful for measuring areas that are physically difficult to reach. They are particularly useful for measuring across rooms, for example to take diagonals, when measuring alone although it is best to avoid lone working.

## 2.6 Keeping safe on site

Site work can be carried out alone but there are good reasons for working in a team of two or three, for example:

■ reduced risk to individual field workers

■ increased speed of working

■ team work draws out more information from the site, as two pairs of eyes are often better than one for spotting tiny or subtle details, and ideas about the interpretation of the evidence can be exchanged

Whether working alone or as part of a team, attention to the wellbeing of the recorder should always be paramount. The type of site to be visited, weather conditions and means of transport will dictate the type of personal protective equipment required. Useful items that should be added to the basic equipment for site work include:

■ antiseptic hand wipes

■ a first-aid kit

■ a hard hat

■ a high-visibility jacket or vest

■ strong boots

■ a waterproof jacket and trousers

■ gloves

Antiseptic hand wipes are important as buildings, particularly empty buildings or industrial sites, can be inhabited by animals and bacteria that can cause disease.

## Box 1: Measuring a plan

**Figure B1.1** Establish a routine for measuring. Measuring in a room-by-room sequence, A (shown in red), B (in blue) and C (in green), will reduce the risk of missing important measurements. If possible running measurements, through adjoining rooms or along corridors, should be taken (X, shown here in purple). As long as the tape is kept straight, and level, it is possible to follow a line of measurement between different parts of a building. This has several advantages in conducting an accurate survey:

■ a series of features and rooms can be tied together through the establishment of a baseline

■ inaccuracies through the accumulation of small errors are reduced

■ the baseline simplifies the process of drawing up the final survey

**Figure B1.2** Start in one corner of the first room. Turn the sketch plan so that the wall to be measured stretches away from the starting point. New starting points for runs of measurements are distinguished in red and blue.

Mark the start point on the plan with a clear arrow pointing in the direction of the measurements or back to the start point (a). Hold the end of the tape on the wall. The tape should be at a comfortable working height which should also make it convenient to pick up most of the features to be measured.

Measurements are taken at each point or feature along the wall noted on the sketch plan (b). It is useful to identify each point when working in a team of two or more,

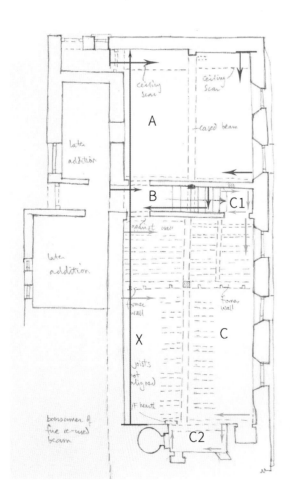

**B1.1**

Measure windows as offsets as shown in Fig B1.3, or separately *see:* **Window openings**

For wall thicknesses, *see:* **Doorways** and **External wall thicknesses**

Cupboard, C1, is measured at the end of the run along the wall, before commencing work along the next wall

Overhead details are measured after the main features of the plan in each room

Fireplace, C2, is measured at the end of the run along the wall, before commencing work along the next wall

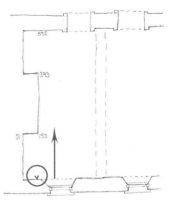
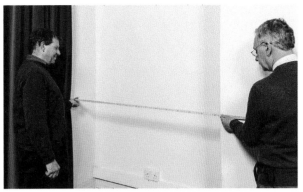

(a)

(b)

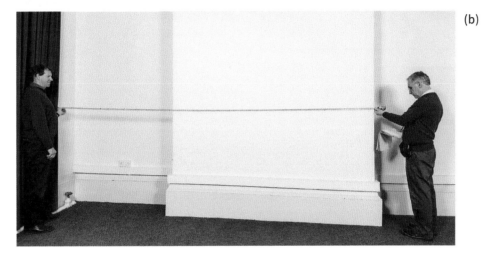

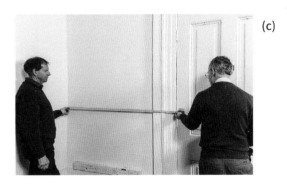

(c)

rather than merely reciting a string of numbers, for example 'side of stack 210', 'window opening 356' and so on. In this way a check can be made that all the features noted on the plan are recorded and the measurements put in the appropriate place.

It is important to keep the tape as taut and as close to the wall as possible to minimise errors.

When it is no longer possible to keep the tape in a straight line the run of measurements is concluded and a new start point established. The site sketch should now be turned so that the next wall to be measured runs away from the start point (c). Another clear start arrow is drawn and the next series of measurements commences.

**Figure B1.3** The position of features that are recessed from the line of the tape can be established by taking an offset measurement, but great care is needed to ensure that the offset measurement is truly perpendicular to the line of the wall (a).

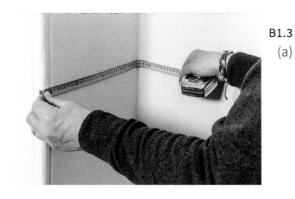

B1.3
(a)

When time is short or there is less need for accuracy, for example for a sketch plan, this technique can also be used to measure window openings (b). It is less accurate than using diagonals and measuring within the recess (*see* Using diagonals and Window openings).

**Figure B1.4** Overhead details, for example beams, can also be measured by offset but great care must be taken or a rod and spirit level are needed if measuring out of reach with a tape.

(b)

measuring this point

shortest distance is at right angle to tape

Recess or splayed window

tape measure

measuring rod or steel tape

Moving the measuring rod establishes the shortest distance

Repeating features, like the jambs of a window, mullions or wooden window frame details, can be duplicated after observation has established that there are no major differences. Clearly measured reference points should be used to locate the features relative to their surroundings. In this way relatively complex details can be surveyed rapidly in the field.

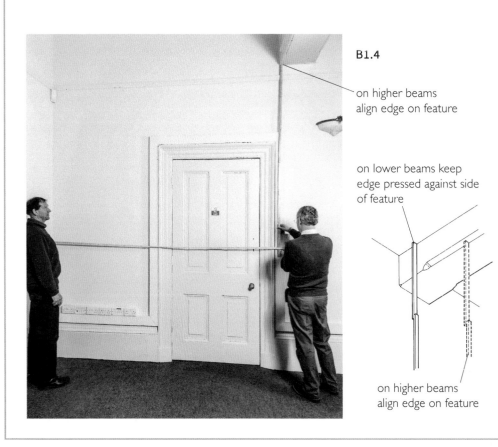

B1.4

on higher beams align edge on feature

on lower beams keep edge pressed against side of feature

on higher beams align edge on feature

21

## Using diagonals

Historic buildings that have been adapted and altered many times are seldom simple rectangular shapes so it is useful to take measurements across each of the main rooms, from corner to diagonally opposed corner, to check possible variations in the overall shape.

**Figure B1.5** Triangulation measurements. These are often referred to as 'diagonals' and are a useful way of defining the overall shape of individual rooms, accurately measuring window openings and other features, or clarifying how parts of a building plan that are set at angles to each other relate if there is no access to more sophisticated measuring equipment. It is worth checking the regularity of room shapes even when the rooms appear rectangular (a).

It is still possible to use diagonals to triangulate points when it is not possible to measure from corner to corner by measuring from and to points measured in the usual circuit of the room walls (b). In this example, diagonals taken in the fairly regular space on the right were drawn up first, providing a number of points from which the spaces on the left could be identified with other diagonals.

**Figure B1.6** Buildings with projecting wings that lie at angles to the main part of the building can also be surveyed by using diagonals linking the various corners of the building. It is a useful aid if the measuring has to rely solely on manual methods without a framework established by digital survey such as a TST survey. A fixed point can be used from which radiating measurements (shown in green) can be taken to the building corners. The main rooms should be measured fully, internal diagonals (in red) being used to establish their overall shapes. Other external measurements, derived from parts of the building exterior are also use to fix the shape (shown in blue).

B1.5
(a)

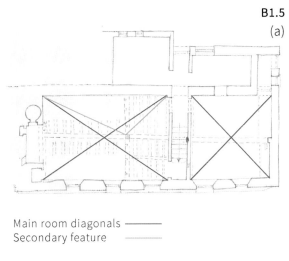

Main room diagonals ———
Secondary feature ———

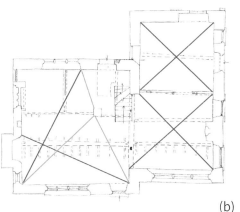

(b)

B1.6

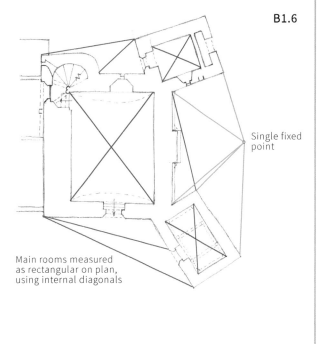

Single fixed point

Main rooms measured as rectangular on plan, using internal diagonals

## Window openings

Using offsets may provide a quick measuring solution for window openings and other wall recesses but more accuracy will result from the use of diagonals within the recess, especially if this can be tied into a framework provided by digital survey. The measurements reflect closely the method of setting out the drawing at the later drafting stage. The basic measurements required are similar for any type of window.

**Figure B1.7** The measurements needed for an opening with a wooden-framed window are similar to those needed for a window with moulded jambs and mullions but slightly fewer are usually needed.

A.  The outer edges of the opening are measured as part of the circuit of the room.

B.  A sequence of measurements includes the side of the opening, the inner face of the opening and further side of the opening. A 'clear edge of the window', the point where the wooden frame is met by the glass, for checking exterior measurements.

C.  If possible, measure through an open window, noting the measurements of the frame. If it is not possible to open the window measure from the glass to the frame, both internally and externally, also noting the inner wall line, external wall line and projection of the window sill if there is one. These measurements are an important

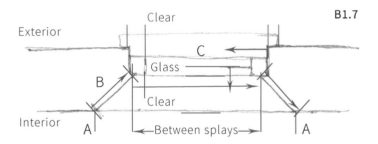

B1.7

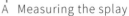
A  Measuring the splay

Clear

Measuring between splays

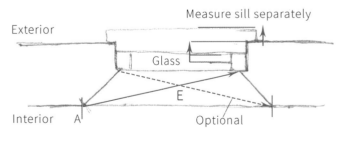
Measuring the diagonal of the opening

means of establishing the thickness of the wall. This type of opening is usually more regular in form than older openings that have mullioned windows so fewer measurements are needed on the exterior. However, it is still useful to note the clear edge of the window for aligning interior and exterior dimensions.

D. Measurements are completed by taking diagonals across the inside of the opening

**Figure B1.8** Mullioned windows. Windows in earlier buildings require more measuring than later examples because the manner in which they were built tends to be less regular. A systematic approach will reduce errors not just in measuring but also in later drawing up.

A. Measure the outer edges of the opening when taking measurements along the circuit of the room

B. Measure along the first splayed side of the opening

C. Work along the inside of the window opening. Note all the changes in surface

as progress is made, particularly the clear edge of the window glazing. This should be clearly visible, and accessible, on both the inside and outside allowing interior and exterior measurements to be fitted together. It is useful to collect more than one of these for a complex window

D. Measure the other splay

E. Starting at the glass, measure points out to the inner face of the window

F. Complete the window by measuring diagonally across the opening from the outer edge to the opposite inner corner. It is worth checking the shape by measuring the other diagonal (shown with a broken line) and noting this if it is significantly different

These measurements should be repeated on the exterior, ensuring that there are sufficient measurements to clear edges to ensure a good fit between internal and external measurements. Measuring from the glass will provide a wall thickness if there are no opening windows or doorways.

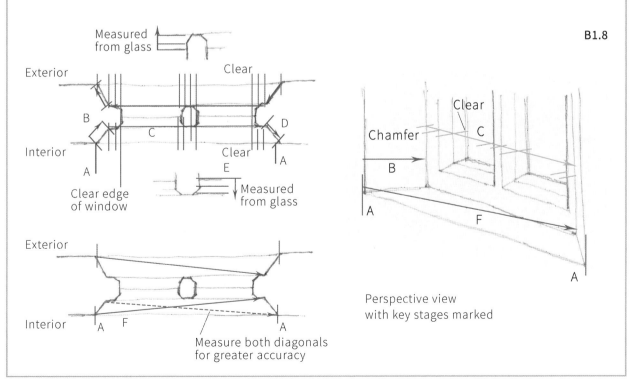

Perspective view
with key stages marked

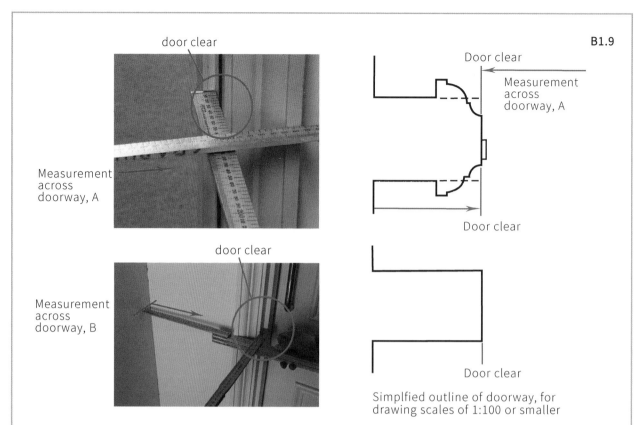

door clear

Measurement across doorway, A

door clear

Measurement across doorway, B

Door clear

Measurement across doorway, A

Door clear

Door clear

Door clear

Simplfied outline of doorway, for drawing scales of 1:100 or smaller

## Doorways

**Figure B1.9** Doorways provide a key means of ensuring that adjacent parts of the plan work together when the scale drawing is being drafted. This needs to be borne in mind when taking measurements on site. Points that are accessible from both sides of the walls are measured. These points are often referred to as the 'clear' of the doorway.

**Figure B1.10** Doorways are also the most convenient places to obtain measurements of wall thicknesses. The amount of detailed measuring needed to record the door surrounds, which are often a focus of decorative treatment that convey the status and hierarchy of the use of a room, will depend on:

- the scale at which the plan is to be drawn

- how the plan is to be drawn, for example with CAD or by hand

- the use of the drawing

In smaller scale plans the detail is simplified, the wall thickness being calculated as shown in (a). It may also be useful to record the full detail of the moulding, either as a larger scale drawing or, if drawn with CAD, incorporated into the plan and isolated as a separate detail. When noting the thickness of the wall it is good practice to distinguish the measurement from nearby running measurements in some way, in this example the number is written within a circle (b).

## External wall thicknesses

**Figure B1.11** The thickness of external walls can be measured through windows. If they do not open measuring to the glass line internally and externally will give the thickness of the wall, the thickness of the glass being too small to affect the overall measurement adversely ( *see also* Window openings). It may be necessary to include a measurement for double glazing units.

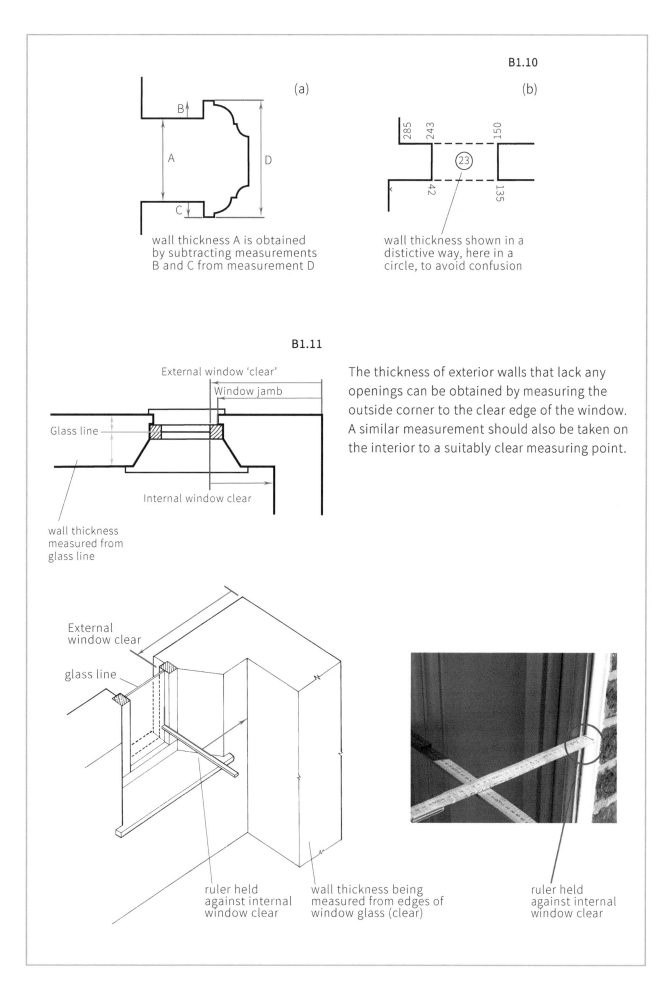

**B1.10**

(a)

(b)

wall thickness A is obtained
by subtracting measurements
B and C from measurement D

wall thickness shown in a
distictive way, here in a
circle, to avoid confusion

**B1.11**

External window 'clear'

Window jamb

Glass line

Internal window clear

wall thickness
measured from
glass line

The thickness of exterior walls that lack any
openings can be obtained by measuring the
outside corner to the clear edge of the window.
A similar measurement should also be taken on
the interior to a suitably clear measuring point.

External
window clear

glass line

ruler held
against internal
window clear

wall thickness being
measured from edges of
window glass (clear)

ruler held
against internal
window clear

## 2.7 Architectural details: mouldings and timber frame joints

Architectural details, such as mouldings, timber joints and iron fittings, are often valuable evidence for dating different phases of a building. For this reason they form an important element in the record. Drawings offer an immediate and easily understood way of comparing mouldings and are a standard tool in the investigation of buildings. They are especially useful when drawn to scale but for rapid analysis in the field simple sketches are often sufficient when working from room to room. The analysis and interpretation that are needed to create a drawing makes the observer more aware of how the various component parts of the moulding relate to each other. Although they are normally drawn and measured separately, they might form an integral part of a plan drawing, for example in a medieval building with moulded window or door jambs, especially when drawn with CAD.

Careful observation is needed to capture the subtle changes of the form. It might also be worthwhile using touch to appreciate very subtle changes of form. Profile gauges are available that allow a full-size tracing of the shape to be made. However, these are quite difficult to use and lack subtlety. Relying solely on electronic measuring devices to measure mouldings is not recommended as it is difficult to capture the subtle detail of the shapes, although they can be used to establish key points on which to add detail later.

Timber framing joints are also often used for dating purposes. Drawing them can additionally yield useful information about the building's structure (Figure 11). Some joints are better understood by sketching them as a 3D object or even as an exploded view as this allows more faces of the timbers to be seen at the same time. Scarf joints, for example, which extend the length of timbers, can be used to help date buildings, as distinctive types of joint were used at certain times in certain places. Side and upper or lower surfaces can be drawn and measured quickly but oblique views allow the joint to be described more fully with few additional measurements. Measuring is straightforward and can be made as simple as possible in the field even when the intention is make a more complex drawing later.

Measurements taken
along the joint ⟶
Measurements taken
across the joint ⟶

**Figure 11**
Site sketches of the different types of scarf joint found at the Old Manor House, Manningham, Bradford and 2 Waterside, Ely, Cambridgeshire.

## Box 2: Measuring mouldings

Mouldings are usually drawn as a profile shape, as if looking at a slice of the feature. These may be horizontal slices of, for example, door jambs or window mullions, whereas vertical slices are drawn for beams. Such mouldings may form part of plans and sections but will also often be drawn, or presented in reports and publications, as larger details.

**Figure B2.1** Simple mouldings, such as chamfers on beams, just need to be measured across in both directions. Care should be taken to keep the measuring device as straight as possible along the sides of the feature to minimise errors. Horizontal measurements are shown in red and vertical measurements in blue.

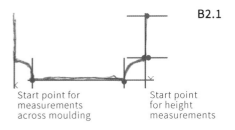

B2.1

Start point for
measurements
across moulding

Start point
for height
measurements

**Figure B2.2** Slightly more complex shapes require more measurements. The aim is to create a simple grid from the measurements, taken as a string of dimensions in each direction. This grid can be recreated on the drawing board or computer screen, and the various shapes can be overlaid, connecting the measured points. Such mouldings are used for door and window jambs, mullions, beams and posts. Horizontal measurements are shown in red and vertical measurements in blue.

**Figure B2.3** The simple grid can be adapted for more complex mouldings. It is worth establishing a routine order in which to take the measurements in order to avoid errors. In this example measurements across the moulded beam were taken first (a). The form of the moulding required a number of measuring points (b), care being taken to ensure that there was a vertical datum to help align measurements and that no gaps were present in the overall sequence of dimensions. Height measurements are then added (c) which can be taken from below or above. The heights of the bottom, a clearly defined middle point and the top from the floor would be useful if the beam is to feature in a section drawing. The result is a grid as shown (d) which will enable the setting out of the drawing. Horizontal measurements are shown in red and vertical measurements in blue.

In this example a 3D sketch (e) was also made on site as a basis for a small number of additional measurements to be noted. This made it possible to produce an isometric drawing clearly showing the form of the decorative detail and the method of attaching the ceiling joists.

**Figure B2.4** Features such as crown post capitals are usually recorded with an elevation drawing for ease of comparison with other examples. Measurements are taken with the aim of producing a grid for later drawing up. Site work can be speeded up by measuring across each segment of the moulding (b). As this type of feature is usually symmetrical, measurements can be copied from one side

B2.2

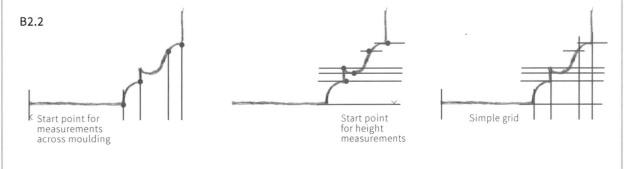

Start point for
measurements
across moulding

Start point
for height
measurements

Simple grid

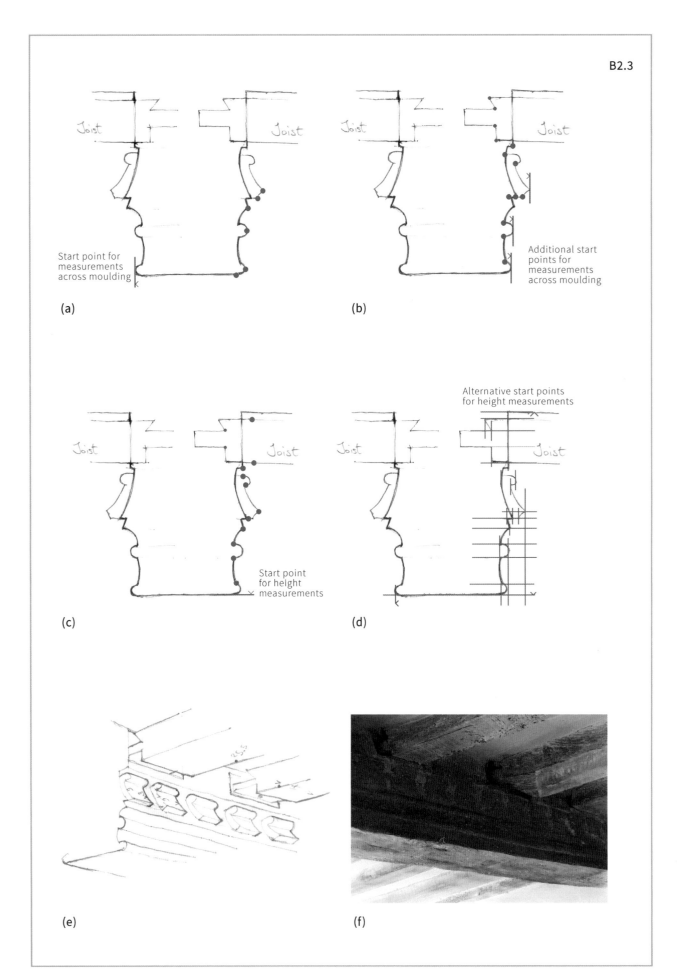

(a) Start point for measurements across moulding

(b) Additional start points for measurements across moulding

(c) Start point for height measurements

(d) Alternative start points for height measurements

(e)

(f)

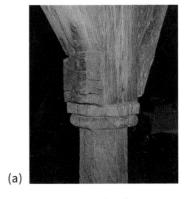

(a)

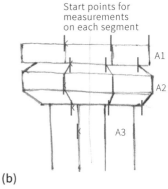

Start points for
measurements
on each segment

A1
A2
A3

(b)

Start point
for height
measurements

(c)

(d)

of the centreline to the other at the drawing-up stage, reducing the number of dimensions needed. Care needs to be taken to ensure accurate measuring across angled parts of the moulding (A1-A3). Height measurements (c) can be taken using the most reliable datum, for example downwards from the flat top of the feature or upwards from the base, the latter being more useful if the feature is to be in a drawing like a section that shows the whole object. A grid (d) can be drawn from these measurements, the points on the left-hand side repeating measurements from the right, mirrored across the centreline. Horizontal measurements are shown in red and vertical measurements in blue.

**Figure B2.5** Staircase balusters are also drawn in elevation. It is useful to note on the sketch parts that are different (in this example some parts are left in square form). In the finished drawing it may be possible to show this differently without a label. The edge of the baluster forms a datum for measurements across, shown in red, while several horizontal edges form useful datums for height measurements, shown in blue.

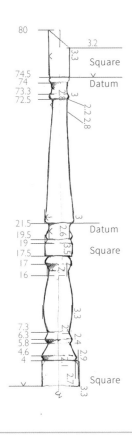

B2.5

80
3.2
3.3
Square
74.5
74
Datum
73.3
72.5
2.8
3
2.2 2.8

21.5
3
19.5
2.6
Datum
19
3.5
Square
17.5
17
2
16

3.3
7.3
6.3
2.1
2.4
2.9
5.8
4.6
2.1
4
2.7
Square
3.3

30

## 2.8 Section drawings

Sketched sections are, like the plan, a key component for analysing the fabric of the building. They not only deal with vertical relationships, of floor heights, ceilings and roof, but also allow for further analysis of building materials and roof trusses. To gain a complete picture of a building several sections may be necessary. The most common starting point is a cross-section, a vertical cut through the building perpendicular to its longest axis. In vernacular buildings this is usually taken at the point of a main division of the building, as this shows the form of the roof, often a key dating feature. However, cross-sections elsewhere will also disclose a good deal of information about the building however and will repay the effort of being sketched and at least partly measured. Measurements can be economically transferred from the plan and other section drawings when a set of drawings is being created.

The terms section and sectional elevation are often confused. The latter is a section that also shows what lies beyond the cut line, as if the building had literally been sliced through. It is usual to omit such background information when drawing a cross-section, though there are occasions when it is useful to draw in the background detail. Long-sections (Figure 12) are vertical cuts through the long axis of the building. It is more common to draw these as sectional elevations as considerably more value will be obtained by showing the relationship between the parts on the cut line and what lies beyond.

(a)

(b)

**Figure 12**
Longitudinal or long-sections may be drawn showing features that would be visible on the line of the cut, in the same manner as a cross-section (a). A sectional elevation (b) gives a better understanding because it places the section in a wider context. Recording for the Early Fabric in Historic Towns: Ely project (RRS 2-2016 forthcoming).

It is at the sketching stage that key decisions about what needs to be drawn will be made, for example whether or not to include later components. On the whole it is better to make a record of what the building is like at the time of survey because, as will be shown below, it is then possible to make interpretative drawings showing the building in various phases. It can also be an aid to measuring to include later features in the site sketch whether they are included in the finished drawing or not.

## Box 3: Measuring a section

**Figure B3.1** The sketch should be drawn after the initial investigation of the building has established the relative significance of individual features and priorities for recording. It should be large enough to:

■ show important features in sufficient detail

■ allow the placing of the necessary dimensions clearly alongside the features being measured

Work across the section to establish where vertical points can be taken. Complex shapes, such as a tie-beam (A), may require a series of points to be measured to enable the shape to be recreated in a drawing.

The drawn structural features can be measured to create a grid of points that can be used to make a measured scale drawing on the drawing board or with CAD. TST survey can also be used to establish these key points to which hand-measured details can be added. Horizontal measurements are shown in red, vertical measurements are shown in blue.

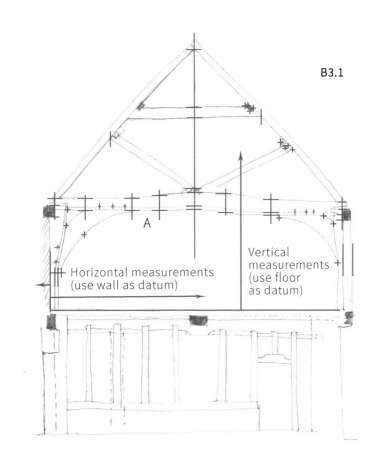

B3.1

A

Horizontal measurements (use wall as datum)

Vertical measurements (use floor as datum)

**Figure B3.2** Features that require many measurements in a small space are best drawn as details so that the noted measurements do not become confused. Features that slope, such as rafters (a) and struts, should be measured across if possible. Curving features may require additional grid points to be measured to ensure the shape is drawn accurately. It is also useful to take some measurements across the feature (b). Horizontal measurements are shown in red, vertical measurements are shown in blue.

B3.2

Roof details

Details of post and brace

**Figure B3.3** Each individual floor will require a set of measurements. In this example fewer dimensions were noted on the lower floor as these were noted on a sketch plan. Although no windows were to be shown on the section measurements were taken at suitable points near the line of the section to enable the thickness of the floor to be determined. These windows need to be shown on the sketch but can be omitted from the finished drawing. Horizontal measurements are shown in red, vertical measurements are shown in blue.

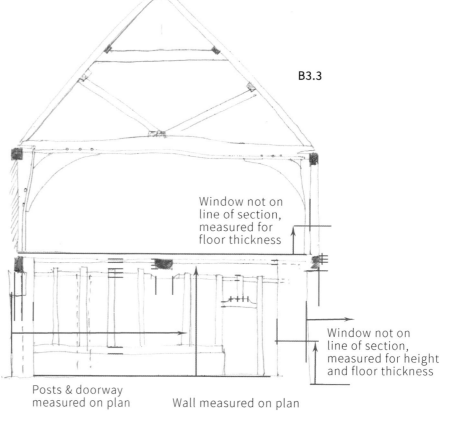

B3.3

Window not on line of section, measured for floor thickness

Window not on line of section, measured for height and floor thickness

Posts & doorway measured on plan

Wall measured on plan

**Figure B3.4** To Measure through floors and ceilings the measurements should be taken through any available openings, for example stair landings and through ceiling hatches (a). It is better to take several measurements than rely on only one, in case there are changes in floor levels. Window sills and the head of openings, that can be seen both inside and outside the building that can be used when there is no means of direct measurement through the floor (b-d). Horizontal measurements are shown in red, vertical measurements are shown in blue. Horizontal measurements are shown in red, vertical measurements are shown in blue.

B3.4

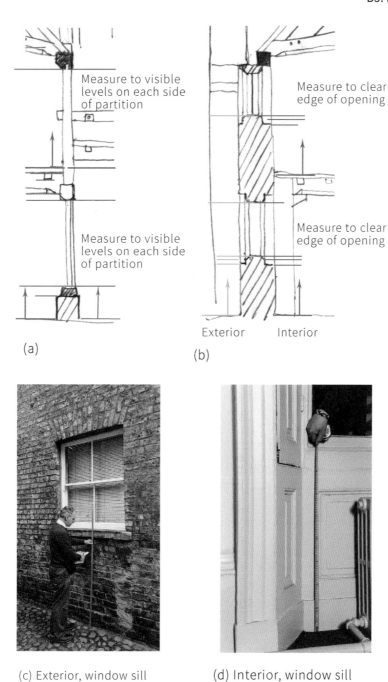

Measure to visible levels on each side of partition

Measure to visible levels on each side of partition

(a)

Measure to clear edge of opening

Measure to clear edge of opening

Exterior    Interior

(b)

(c) Exterior, window sill

(d) Interior, window sill

## 2.9  Improvising datum lines

When the building does not provide horizontal and vertical surfaces for establishing measuring points, it is necessary to make temporary datum lines. A string line and level can be used to set up a horizontal datum. Height measurements are taken at regular intervals to the datum and the features being measured, thus forming a grid for later drawing up. Walls can deviate from the vertical, in which case measurements should be taken to a number of points that are recorded in both height and horizontal distance from a vertical surface that has been checked to ensure it is vertical (Figure 13a). A horizontal feature such as a roof line can also be used to check height measurements on uneven ground, with check measurements to the eaves being taken whenever features in the drawing are measured (Figure 13b).

## 2.10 TST surveying

The direct measurement of historic buildings described here can be supported by a number of electronic survey techniques. Hand-held laser-measurement devices are available that greatly assist the measuring of diagonals, especially when working alone, and in buildings that present physical obstacles to measuring, for example missing areas of floor.

A TST, incorporates distance, as well as angular measurement, and is particularly valuable for use on large or more complex sites, and can be used when greater accuracy is required. It is a powerful tool for this type of recording when combined with hand-measured survey, being used principally to provide an accurate framework holding the building envelope together, but is not recommended for the measurement of details such as mouldings. As survey work is logged in a 3D environment it can also be used to record points not accessible for direct hand measurement without the use of scaffolding or other access equipment.

Data can be fed directly into CAD packages on site which can help speed up survey work and help reduce errors of omission. The use of CAD requires a high degree of investment in equipment and training and is therefore beyond the scope of this guidance. Numerous technical manuals for undertaking this sort of survey work are available, along with guidance for using the equipment for surveying historic sites (Andrews *et al* 2010; Bedford *et al* 2015).

The integration of TST and hand-measured surveys usually takes place after the survey work is completed. Hand-measured elements can be incorporated into the digital drawing in the same way as building up a drawing by hand when the survey is being finalised. If the drawing is being made by hand the TST survey can be plotted at the required scale and used as an underlay for the draft drawing.

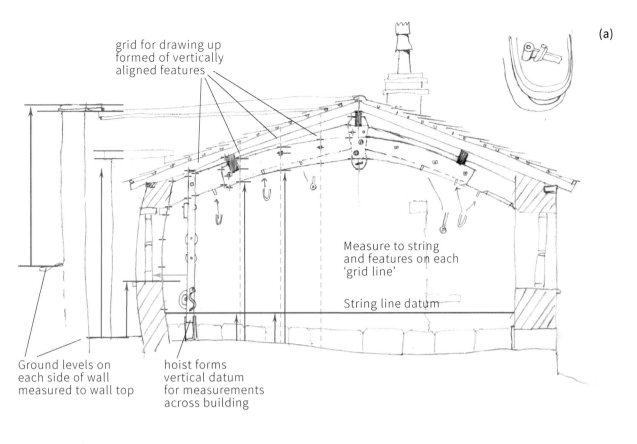

grid for drawing up
formed of vertically
aligned features

(a)

Measure to string
and features on each
'grid line'

String line datum

Ground levels on
each side of wall
measured to wall top

hoist forms
vertical datum
for measurements
across building

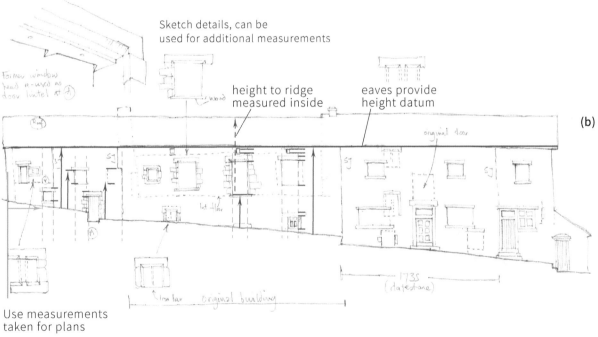

Sketch details, can be
used for additional measurements

height to ridge
measured inside

eaves provide
height datum

(b)

Use measurements
taken for plans

**Figure 13**

String and a spirit level were used at the deer slaughterhouse in Levens Park, Levens, Cumbria, because of the uneven floor (a). The slightly bulging wall to the left was measured at a number of points from the ground and the hoist, which was found to be vertical. The grid for drawing up was derived from a series of height measurements taken in lines that corresponded to details that were measured across the section. The eaves of the newly built roof of Annatt Walls, Alston, Cumbria (b), were used as the datum for height measurements along the façade. Colours are used to differentiate different grid lines, labelled within the diagram. *See* Jessop *et al*, 2013 *Alston Moor, Cumbria: Buildings in a North Pennines Landscape.*

# Case Study 2

## 33 High Street, Ely, Cambridgeshire

### Introduction

This building was surveyed as part of a project on early building remains in historic towns. Such surviving fabric in urban areas is often very fragmentary, as buildings are frequently adapted for new uses; 33 High Street is a good example of this type of complex development. Although it was inaccessible at the time of the survey it was reported that there was a good quality 13th–14th century undercroft beneath the present, 18th- and 19th- century building which is now used as a retail shop, with 20th-century shop fronts on the ground floor and storage areas above. A single bay of a 16th-century timber ceiling remains that retains evidence of the original layout of the building (Figure CS2.1).

### Survey method

The recording of the ceiling posed a number of challenges:

- all the surviving timbers were overhead, not at ground level

- the survey had to take place on the retail floor, during shop open hours, among clothing racks and without inconveniencing shoppers

An improvised method was devised to measure a sketch plan of the remaining timber frame. A height pole was used to establish a starting point for horizontal measurements, using a spirit level to ensure it was positioned vertically beneath the first beam. To this was attached the end of a measuring tape.

**Figure CS2.1**
A single bay of 16th century ceiling survives within a modern retail shop (a). A good deal of evidence about the earlier form of this building was gleaned from the timbers, especially empty timber joints and the style of carved decoration (b). (Early Fabric in Historic Towns: Ely project RRS 2-2016 forthcoming).

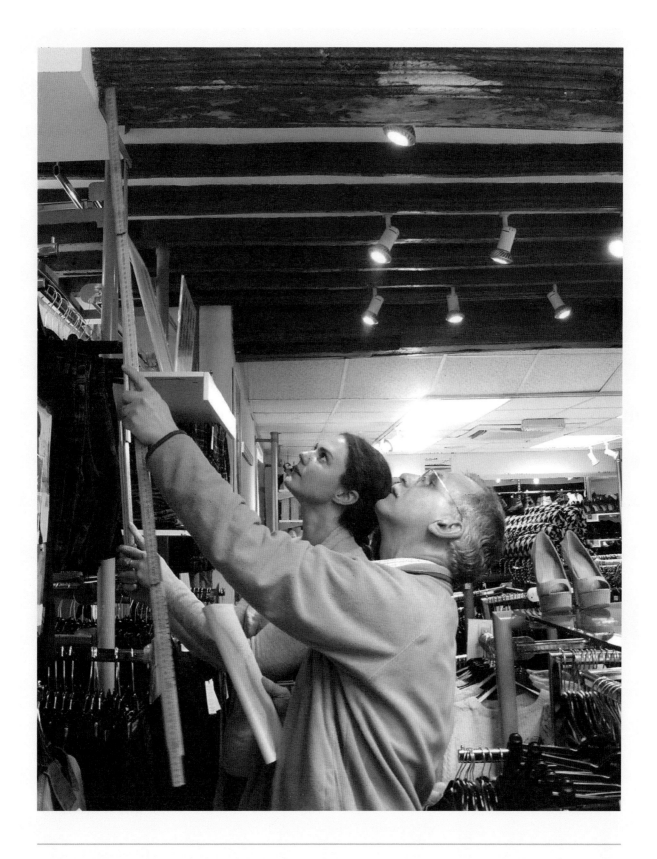

**Figure CS2.2**
Recording the remaining timbers was a challenge
as it had to be done without inconveniencing staff
or customers.

## Ground-floor plan

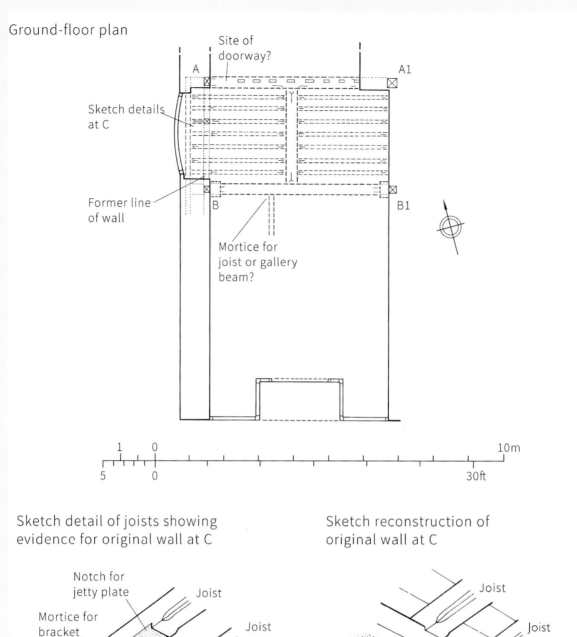

Site of doorway?

A          A1

Sketch details at C

Former line of wall

B          B1

Mortice for joist or gallery beam?

1   0            10m

5   0            30ft

### Sketch detail of joists showing evidence for original wall at C

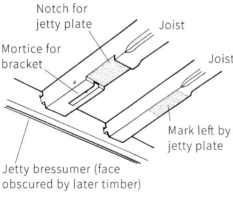

Notch for jetty plate

Joist

Mortice for bracket

Joist

Mark left by jetty plate

Jetty bressumer (face obscured by later timber)

### Sketch reconstruction of original wall at C

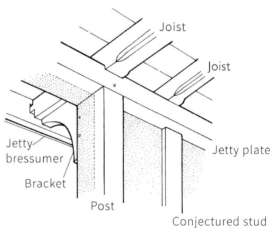

Joist

Joist

Jetty bressumer

Jetty plate

Bracket

Post

Conjectured stud

**Figure CS2.3**
The completed drawn record included a reflected plan of the ceiling and sketches showing the evidence for the original timber frame found on the joists.

39

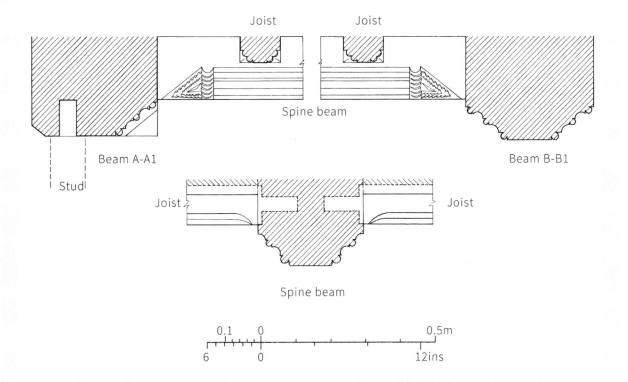

Joist          Joist

Spine beam

Beam A-A1

Stud

Beam B-B1

Joist                    Joist

Spine beam

0.1    0                        0.5m

6      0                       12ins

**Figure CS2.4**
The record drawings also included measured
details of the moulded beams. These were used to
establish an approximate date by comparing them
with similar examples already published.

Folding rods, held vertically underneath the
beams, were then used to take horizontal
measurements, again using a spirit level to
ensure accuracy.  Measurements across the
width of the building were taken in overlapping
stages to keep disruption to a minimum.
The carved decoration of the ceiling beams
was an important aid to dating the structure
so the mouldings were carefully drawn
and measured. Sketch details of evidence
of former walling and timber joints were
made on site as it was difficult to record
these with photography (Figure CS2.2).

### The drawn record
The fragmentary remains of the timber frame
and challenging conditions for measuring the
plan meant a sketch plan was the best means
of placing the ceiling in the context of the
later building. Detailed measured drawings
were made of the moulded beams to allow

comparison with other, dated examples.
Research on other urban examples prior to
the fieldwork suggested a range of building
types that the project might find. Post-survey
research found a good stylistic match for the
carved decoration, firmly dated to 1520. A
reconstructed sketch plan and long-section
were drawn to make sense of other structural
evidence (Figures CS2.3 and 4).

### Conclusion
The survey of 33 High Street shows how
worthwhile it is to record even fragmentary
remains of early buildings. The moulded ceiling
beams revealed a good deal about the date of
the building and about how it was constructed.
Less fragmentary examples of similar buildings
were discovered by further research which
meant more could be done with the evidence
than was originally anticipated (Figure CS2.5).

Conjectural reconstructed long-section

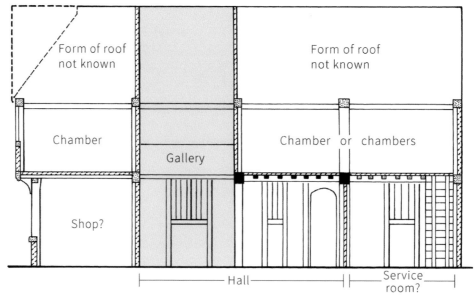

Conjectural reconstruction of ground-floor plan

HIGH STREET PASSAGE

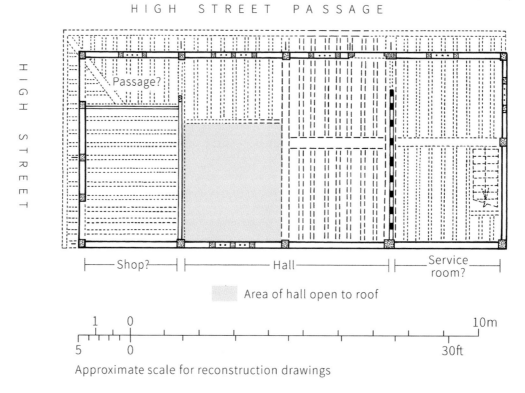

Area of hall open to roof

Approximate scale for reconstruction drawings

**Figure CS2.5**
A conjectural reconstruction was drawn, as
the evidence found here was similar to several
examples of buildings from other towns.

41

# 3 Measured Drawings

The reasons for which the record is being made will determine the type of drawings required at any particular site. Sometimes roughly dimensioned site sketches will be sufficient and these should be included in the finished archive, possibly also being reproduced in some way for a report. Usually, however, the sketching and measuring done on site will form the basis of measured drawings. The presentation of the finished survey is a very important part of the recording process. It is essential that the final drawings are clear and easy to read as well as being an accurate representation of the site.

## 3.1 Equipment for drawing up surveys

The equipment needed to produce measured drawings from field surveys need not be complicated or expensive. While computer equipment is mostly beyond the scope of this guidance, it is worth pointing out that various software options are available that will produce a similar result to the type of drawings described in this guidance. For hand drawing there are numerous equipment options available with a range of prices. Personal preference, budget, available working space and the intended use of the finished drawing determine what equipment is required (Figure 14).

### Drawing boards

For simple surveys of small buildings plastic drawings boards that can be taken into the field are economical on space as well as being relatively inexpensive to buy. They are usually for A3-size paper and are equipped with a ruled, sliding bar that acts as a parallel motion. Drawings that will fill a sheet of A3 paper require a larger, A2–A0 size, board for comfortable working, and the board should be capable of being inclined from the flat. Fitting a parallel motion is also an efficient addition to the board, although a T-square could be used to help keep drawn lines horizontal. It is best to attach a sheet of thick white paper or thin card, which can be easily removed when it becomes dirty or damaged, to the drawing board before starting work on it. This will:

- provide a better working surface by absorbing some of the pressure exerted through the pencil while drawing

- give a brighter background to tracing paper or film

- help to keep the surface of the drawing board clean, absorbing graphite dust and minute debris from erased marks from the drawing

Working for long periods on a flat board can strain the recorder's neck and shoulder muscles. It is advisable to take regular breaks and move around to prevent discomfort and avoid long-term injury from repetitive movements.

### Drawing surfaces

Almost any type of paper can be used for drafting purposes, although smooth white cartridge paper or illustration board is recommended. This provides good visibility, especially for light

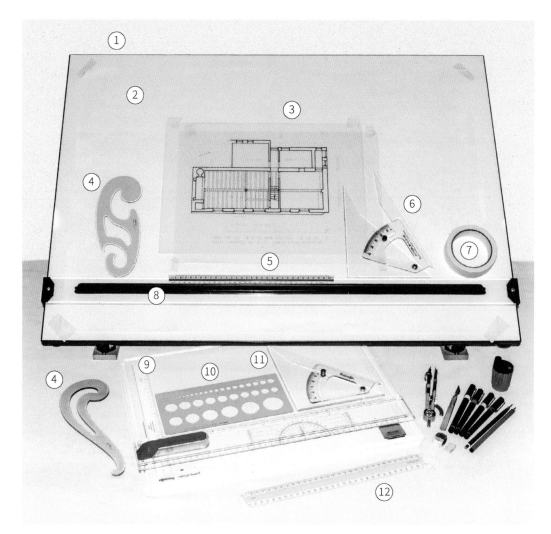

Basic drawing equipment

1 Drawing board, A1 size
2 Cartridge paper backing sheet
3 Polyester drafting film
4 French curves (part of set)
5 Scale ruler (1:100, 1:50, 1:20, 1:10, 1:5)
6 Adjustable set square with inking edges
7 Masking tape
8 Parallel motion
9 Plastic A3 drawing board with
  parallel motion
10 Circle template
11 Adjustable set square
12 Scale ruler (1:100, 1:50, 1:20, 1:10, 1:5)
13 Compasses
14 2mm pencil leads and lead holder
15 Spare leads
16 Sharpener for 2-mm pencil leads
17 Technical drawing pens, sizes 0.18,
  0.25, 0.35 and 0.5mm
18 Scalpel for correcting ink drawings
19 Eraser for pencil and ink
20 Erasers, cut for detail work

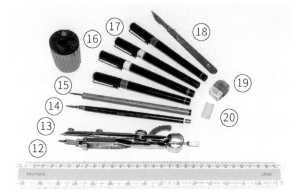

**Figure 14**
Equipment for drawing up the survey.

pencil marks, allows erasers to lift the graphite easily when correcting mistakes and does not allow graphite dust to accumulate, which helps to keep the drawing clean. Thinner paper is not recommended as the surface can rapidly degrade with heavy working and repeated corrections.

For most survey drawings good-quality tracing paper of 90gsm weight is more suitable, especially for complex drawings and multiple sections or plans of the same building. This gives the following:

■ a fine surface grain that is good for use with pencils

■ a robust drawing surface that allows corrections with an eraser

■ transparency which allows overlay working, enabling selective drawing or tracing on one sheet and the ability to see through to an underlying drawing

Creating finished drawings with pen and ink is also made easier if a transparent paper is used. Polyester drafting film is more suitable for finished drawings as:

■ it provides a smoother surface for technical pen nibs, giving more consistent line thicknesses

■ errors are easier to correct (using a scalpel and an eraser)

■ it is better for long term dimensional stability

Illustration board can also be used for drafting and finished drawings but lacks the transparency useful for overlay working. Pencil construction lines can be removed by eraser when the finished ink lines are dry, but it is difficult to keep the surface intact after intensive work and large amounts of rubbing out.

## Pencils

Any sort of pencil can be used for the drafting of measured drawings. It should be borne in mind, however, that some types, especially pencils with very soft leads and relatively blunt points, will affect the accuracy of the drawing. At a scale of 1:100, a 0.5mm line is 5cm thick. It follows therefore that the best pencil to use for drafting is one that:

■ can be sharpened to a fine point

■ retains the point for as long as possible to reduce the frequency of sharpening

■ is not prone to snapping under light pressure.

The hardness of the lead required is determined by the type of paper that is to be used and the amount of detail that is expected to be incorporated into the drawing at a given scale. Tracing paper requires a very hard lead, 4H or 6H, otherwise the point wears very quickly and the surface of the paper soon becomes covered in graphite dust. Leads for mechanical pencils are available only in limited degrees of hardness, partly because they are difficult to manufacture.

Experience has shown that 2mm 4H or 6H leads in a lead holder tube, sharpened with a lead pointer, is one of the best pencils for drafting measured drawings on tracing paper or drafting film. For drawing on smooth cartridge paper, 0.3mm HB or H leads work very well.

Digital tablets with various forms of stylus are available for use with computer packages. Some of these have characteristics, provided by the operating software, which enable them to mimic the actions of traditional drawing instruments.

### Pens

Technical pens produce precise, consistent ink lines without the application of pressure. Pens from different manufacturers may differ slightly in operation, but all produce pens in standard point sizes. These range from 0.1mm to 2mm in thickness. An initial set of pens for building survey drawings should include point sizes:

- 0.18mm

- 0.25mm

- 0.3mm

- 0.5mm

These will provide a range of line thicknesses that will allow clear drawings to made using the drawing conventions recommended in the Appendix.

### Other equipment

There are many other pieces of equipment that will assist with drawing up surveys by hand. The most useful are listed below:

- Scale rulers. These have gradations marked on their edges that allow scale drawings to be measured directly. They are available in both metric and imperial versions

- A set of compasses. These are essential for the initial setting out of plan drawings and for accurate drawing of rounded arch forms in sections and elevations. They should be large enough to allow for arcs that describe diagonal measurements across rooms, or be extendable with a beam attachment. Very small radii are also sometimes required. Attachments that allow technical pens to be used with them are useful

- Triangles or set squares. These are available with angles of 30, 45 and 60 degrees. Adjustable triangles are perhaps the most useful. They should ideally have a raised edge to prevent technical pens leaking ink underneath

- French curve templates that provide a support against which to guide pens and pencils while drawing a variety of broad and tight curves

- Circle and ellipse templates, for guiding pencils and pens while drawing these shapes

- Good-quality plastic erasers for pencil and ink. Errors in ink drawings can also be removed with scalpel or razor blades. The drawing surface may need additional treatment from an eraser to restore the surface for fresh ink

## 3.2 Scale

The size of the building and the desired level of detail will be the main factors influencing the drawn survey of buildings. This becomes particularly important when drawing up the survey, especially when drawn by hand. Typical scales are:

- 1:100 or 1:50 for plans

- 1:50 for sections and sectional elevations (1:100 for larger buildings)

- 1:50 or 1:100 for elevations

- 1:5 for mouldings, or 1:10 for larger features, for example doors or panelling

- 1:20 for timber framing joints, constructional details

- larger buildings and complexes might be drawn at smaller scales, for example plans might be prepared at 1:200 or 1:500

- bird's-eye views, for example of several buildings on a site such as a farmstead, might also be drawn at smaller scales, such as 1:100, 1:200

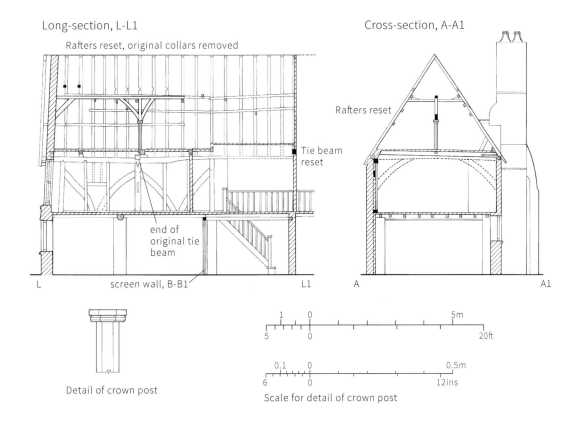

Long-section, L-L1

Rafters reset, original collars removed

Tie beam reset

end of original tie beam

L    screen wall, B-B1    L1

Detail of crown post

Cross-section, A-A1

Rafters reset

A    A1

1    0    5m
5    0    20ft

0.1    0    0.5m
6    0    12ins
Scale for detail of crown post

**Figure 15**
The sectional elevation and cross-section were drawn at 1:50 scale, the detail of the crown post at 1:5. All were reduced to 50% to illustrate the report on the building, 23 Broad Street, Ely, Cambridgeshire and are shown here slightly smaller than they were in the report. Recording for the Early Fabric in Historic Towns: Ely project (RRS 2-2016 forthcoming).

Quite often drawings are reduced, frequently to 50% or smaller, for publication. Scale is also a factor in the preparation of drawings with CAD. While computer drafting may use actual measuring units the final product usually needs to be printed in some form and the scale of the print or plot will therefore determine the level of detail of the drawing (Figure 15).

Once these factors have been taken into account the same basic techniques will work equally well on a drawing board or with CAD. The basics of measurements and problem solving remain very similar irrespective of whether a pencil or computer is used to draw the lines. There are various CAD packages available, some are expensive and others free to obtain, varying greatly in ease of use and capability, a limiting factor being the expertise and experience of the user. The techniques being described here can be used with basic equipment, either electronic or hand held, that is readily available, to produce reasonably accurate drawings. They can also be combined with information obtained from digital survey, a technique that offers the best combination of survey work: accuracy from the instrument survey and close observation and intimate contact with the historic fabric through hand measurement.

## 3.3  Simplified drawings

The simplest forms of measured drawings, for example sketch plans and sections, can be prepared quickly from the most basic measurements collected on site. Lacking in details and accuracy, they tend to be based on only the main dimensions, and assume rooms to be regular in shape. They tend, therefore,

to be drawn at the smaller scales. These drawings can be used to illustrate a summary report that is produced under severe time constraints. They are also useful as part of a larger, thematic study when drawings might be used for comparative purposes, with more detailed drawings used to illustrate the best examples of the type of building or site being studied. Knowing that this is the case at the outset of the survey is clearly necessary to ensure that the survey collects all the information needed for the level of drawing to be made.

## 3.4  Products

Site surveys used for analysis require more accurate drawings which can be produced using the field survey techniques illustrated above. A set of drawings would consist of all or some of the following:

- a measured plan of the principal floor

- one or several cross-sections (to illustrate vertical relationships and roof truss types)

- a long-section or sectional elevation

- details of mouldings

- details of the joints in timber framed buildings

Measured details of mouldings and joints are particularly useful when the features in question are aids to dating.

The actual composition of the set of drawings will depend on the site and the aims of the survey project. Several plans of the main floors, for example, may be required, along with several sections. More modern buildings or industrial complexes, including farmsteads, may require a different set of drawings entirely, including site plans at larger scales or bird's-eye views to show the relationship of buildings within the complex and different sizes of building.

When starting a set of record drawings it is helpful to consider the set in a similarly structured way to

that employed in the field. It is good practice to work through the set of drawings in a logical order, for example starting with the plan and working through the section drawings in turn, with cross-sections usually drawn before long-sections. This enables best use of the information collected on site and can speed up preparation of the complete set, as some measurements can be used for more than one drawing and checks for accuracy made as work progresses. Drawing the plan first is very useful, as this provides the starting point for all the other drawings and places each component of the building into a defined context.

## 3.5  Working procedure

It is generally best to make a draft of each drawing, irrespective of whether it is being drawn by hand or not. Alterations and adjustments will be necessary while making the draft, or possibly numerous drafts. Making a separate, finished, drawing, once the draft has been checked and improves the presentation of the survey. For hand-drawn surveys this usually entails a pencil draft, which is easier to amend, and a finished drawing in a more permanent medium such as pen and ink.

The process of drawing up is generally straightforward if tackled in a methodical way. Each person will have his or her own tried and trusted method, and each site will present its own challenges, but the methods outlined below should serve as a useful guide for making an accurate set of drawings from a hand-measured survey.

## 3.6  Drawing plans

The collection of measurements in the field should provide the means for setting out a plan using the building as its own grid. Using arcs to establish key points, either measured along walls or via diagonals across a room, a plan can be quickly and accurately laid out. The aim should be to work from larger volumes, for example the overall shape of a room, to smaller, more detailed

volumes and details, following the survey maxim of 'working from the whole to the part'.

It is best to work in a logical sequence for each room, checking carefully any interconnecting features, such as doorways or structural features visible on both sides of a wall. In this way minor discrepancies in the measurements can be considered as they are drawn. When the drawn walls appear not to meet, particularly noticeable when working with CAD, the most common reason is a misreading of the dimension when setting

the arc. Another common error is not keeping the tape taut when on. Smaller errors, of 20-30cm, can be overlooked, especially when drawing at a scale of 1:100 or smaller. Larger errors should be checked by looking again at the site notes and then redrawing the arcs. If this does not resolve the problem it may be necessary to work up the next room and redraw the problem area. Historic buildings seldom have perfectly flat walls and regular corners; these factors and minor, imperceptible, changes in angle can have a marked effect on detailed measurements.

---

## Box 4: Drawing a plan

### Starting the drawing

**Figure B4.1** The basic method is applicable to both drawing by hand and using CAD.

- Draw a line marking the key points from the site sketch along the longest continuous run of measurements

- The letters identify room corners, red lines new measurements and drawn lines

**Figure B4.2** The other corners of the first room are located by drawing arcs, shown in green, from A and B, the latter, Bb1, being the diagonal measurement across the room. The intersection of these arcs marks the corner at C.

**Figure B4.3** Corner D is located using arcs from A and B in similar fashion.

- The distance between C and D should be checked for accuracy before drawing in the wall line

- It is sometimes necessary to adjust these early drafts after other rooms have been added. The arcs may need to be started from opposing points to enable a better fit of the measurements

**Figure B4.4** Repeat the process for the next large room using diagonals to set the corners, if possible.

- The line of wall L-K in the diagram is incomplete because it is interrupted by a small projection with asymmetrical sides.

- Wall lines E-F and G-H were copied from the wall lines of the larger rooms, the distances being the wall thicknesses noted on the site sketch

**Figure B4.5** The end wall can be completed by adding the detail measurements to locate the projection in wall L-K. This should resolve the problem of the wall being slightly thicker in one part compared with the other. Detail measurements are added to enable the narrow central room to be worked out.

- Details include beams and posts that align on the site sketch

- Doorways also allow wall thicknesses to be measured in

**Figure B4.6** Using the doorways as starting points, the rear wall and some of the central space, including the inside of the front wall, are drawn in.

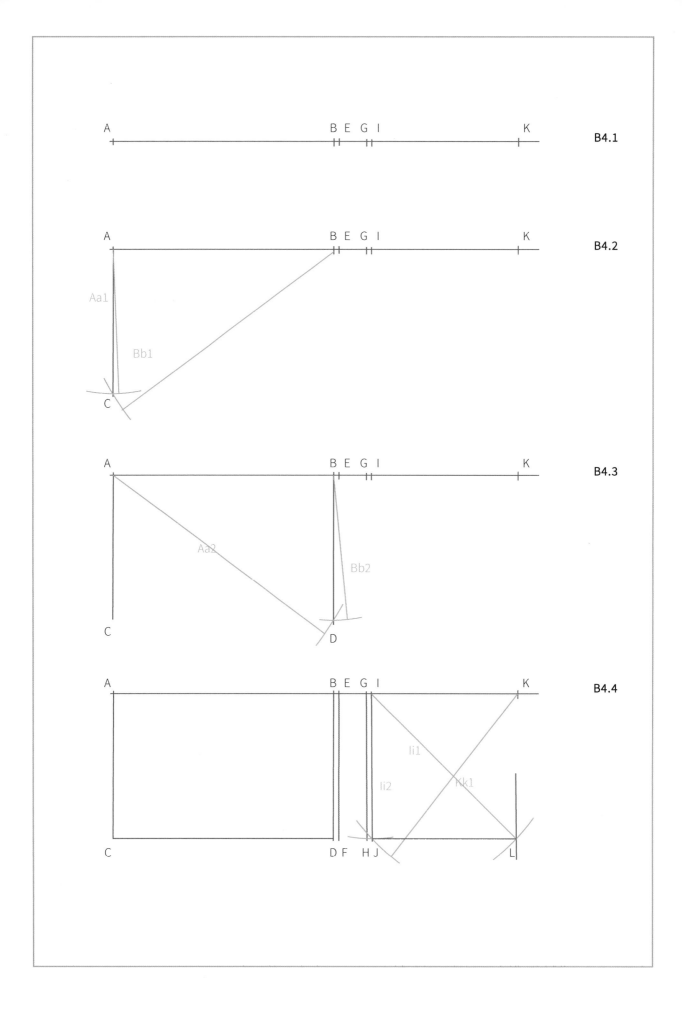

A        B E G I            K    B4.1

A        B E G I            K    B4.2
Aa1
Bb1
C

A        B E G I            K    B4.3
Aa2
Bb2
C        D

A        B E G I            K    B4.4
Ii1
Ii2          Kk1
C        D F  H J          L

49

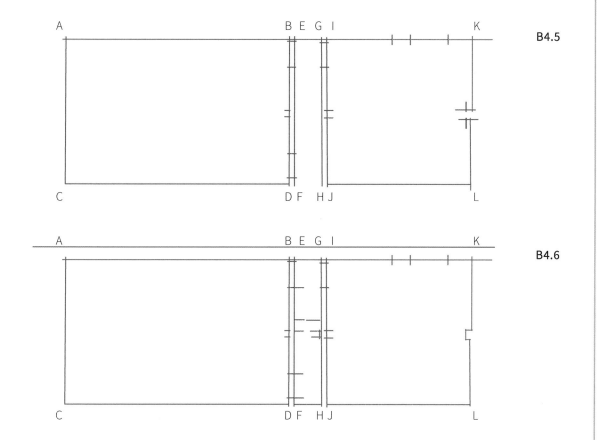

## Adding details

Having set out the main room spaces details can now be added. A systematic approach similar to that used on site reduces errors.

**Figure B4.7** In the main room, marking out the windows can be started. Locating the window openings will help establish the main wall features of the room. Marks are also measured in to locate a small deflection in the corner of the room.

**Figure B4.8** Window details are drawn with a sequence of diagonal arcs.

- Set the compass to the length of one of the window splays and draw an arc from the measured point of the window opening (a)

- A second diagonal arc should be drawn from the far side of the opening to fix the position of the end of the splay

- An arc drawn from this point, set to the length of the inside of the window, will help to position the end of the other splay which should be drawn with another arc from the window opening (b)

- The main parts of the window can be drawn at this stage (c)

- Measure the glass line and window edge clears (d). Putting the glass line in gives a measuring point for the external wall line

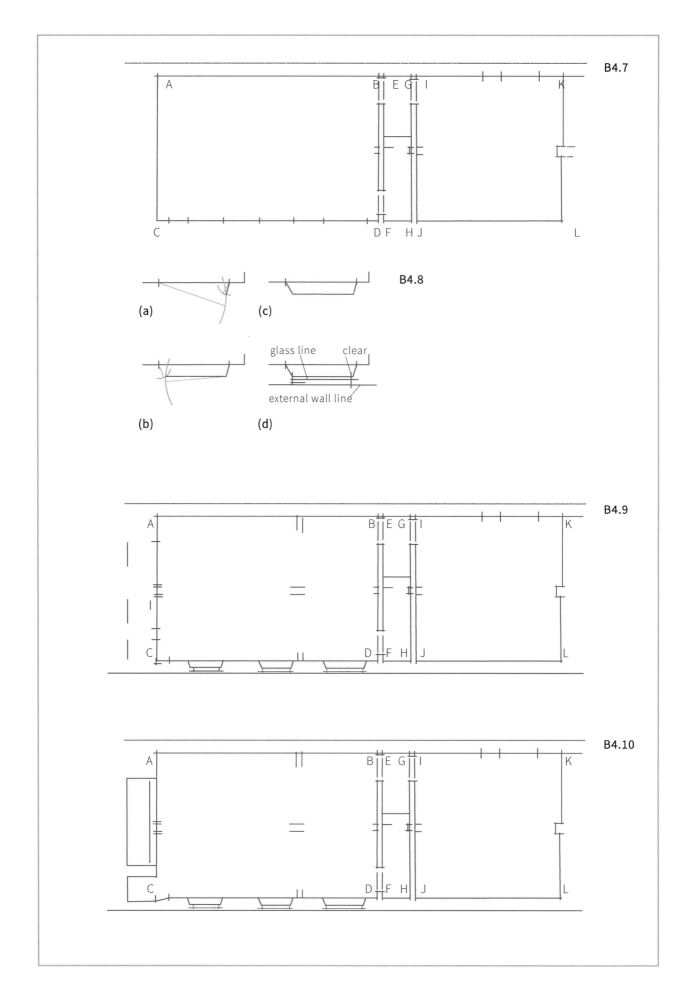

B4.7

B4.8

(a)

(c)

(b)

glass line    clear

external wall line

(d)

B4.9

B4.10

B4.11

(a)  centre point  (c)

(b)  (d)

B4.12

B4.13

grid north arrow    later additions    not fully surveyed    B4.14

**Figures B4.9-11** After drawing the windows, work around the room adding further details. Complex features such as fireplaces and ovens will require a sequence of actions.

- In this example the mouth of the oven was marked first (11a)

- The deepest part of the circular shape was marked next (11b), the cross shape from the corners denoting the centre point. This was used for a circle template or compasses to be used to draw the circular shape of the oven interior (11c)

- The completed oven is shown (11d) with the construction lines removed

**Figures B4.12-14** The remaining illustrations show the completion of the draft plan.

- Exterior details are added after completing the main interior rooms, these measurements being checked against the interior details for the windows to set the thickness of the end walls

- Later additions to the rear were included to complete the detailed part of the plan although only the main measurements were taken on site

## 3.7 Drawing architectural decorative details

Before dating techniques such as dendrochronology became available buildings were often dated on stylistic evidence. At the heart of this dating method were decorative details such as mouldings. This created a need to make measured drawings of mouldings so that they could be compared more easily and accurately from building to building, the measurements recording subtle differences that can be crucial in determining dates. The combination of scientific dating and comparative drawn detail is still an important means of establishing when a building, or part of a building, was constructed as the details are usually an integral part of the structure.

Drawn records of mouldings usually take the form of profiles or sectional drawings that replicate a slice through the timber or stonework. Some details, however, such as decorated posts in roofs and stair balusters, are drawn in elevation although a section may also be used to clarify the form in similar manner to that used for archaeological finds.

Both types of drawing can be made using a simple grid derived from the site measurements of the objects. It may be useful to make these drawings while working on plans and sections, especially if working with CAD, as the details will also form part of the plan or section. When making hand-drawn records, working out the details in advance or at the same time as the plan or section can be useful, facilitating a better picture of how the detail will look. It might also be possible to reduce the detail photographically and incorporate it into the draft drawing.

## Box 5: Drawing a moulded beam and a moulded post

### Drawing a moulded beam in section

**Figure B5.1** The complex moulding shown here was drawn up using a series of grids.

The starting point was a baseline (A) derived from the most accessible part of the moulding, which also served as a horizontal datum. A partial grid was constructed, working upwards from the datum line. The straight rear face of the beam (B) provided a vertical datum.

On site measurements sometimes start from other points, but grids can be drawn from any marked point on the drawing. Horizontal measurements are shown in red, vertical measurements are shown in blue.

**Figure B5.2-3** Building up the grid in stages to set out parts of the feature in turn avoids any confusion that may arise from having too many unconnected grid points on the drawing. In this example older grid lines are shown in paler colours. Small circles may need to be plotted from centre points derived from the grid (D).

**Figure B5.4** Further grid marks are added as measuring moves up the moulding, with further circles added as needed. With practice these shapes may be drawn freehand, especially at smaller scales. The shapes should be carefully checked against the site sketch and photographs.

**Figure B5.5** The complex upper part of the moulding is measured from a new datum (E).

**Figure B5.6** The completed draft of the moulding. Any parts not completely visible should be indicated differently, in this example by means of a broken line.

### Drawing a moulded post in elevation

**Figure B5.7** To draw a moulded post in elevation set out two grids for both the upper and lower parts of the post. It is not generally necessary to draw the whole post, except when the capital and base are relatively closely spaced. The top edge (A) makes a useful upper datum while the lower edge of the base (B) makes a good level datum for the lower portion. Horizontal measurements can then be marked, measuring downwards from the top and upwards from the bottom (or in a continuous run for a shorter post). A centreline (C) should then be drawn.

**Figure B5.8-10** Points across the moulding can then be measured in, the centre point being found between the two measurements across the central part of the three facets visible in the elevation (D). Measurements are then added for the left and centre facets for each horizontal tier, care being taken to check the profile of the drawn faces against the site sketch and reference photographs. Place measured check points to the other side of the centreline (E).

**Figure B5.11** The completed profile and details from the left of the drawing can be copied as a reflection to complete the drawing.

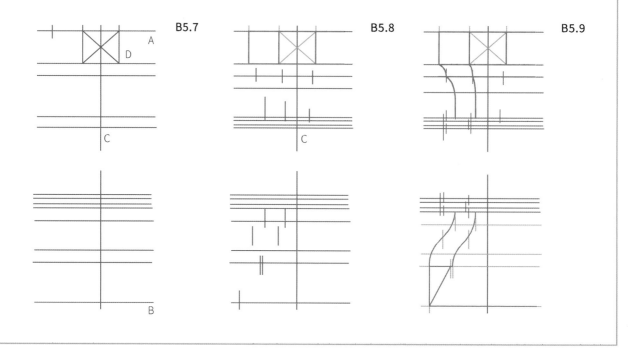

B5.7  B5.8  B5.9

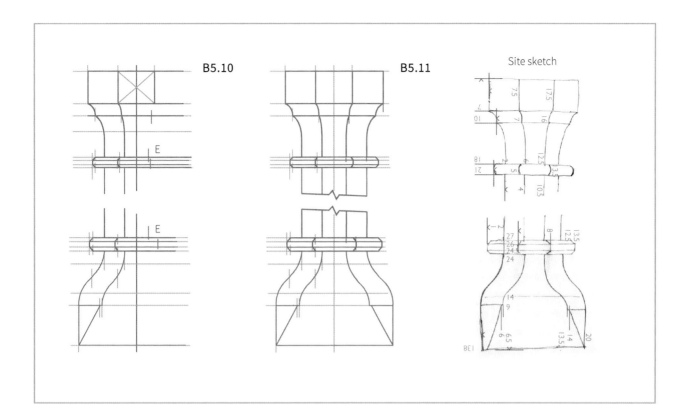

B5.10    B5.11    Site sketch

## 3.8 Drawing sections

Sections are drawn using a series of grids, also derived from measured points within the building. The starting point is a grid that includes datum lines checked on site for accuracy or set up using spirit levels and plumb lines; they are usually the walls and floors. As with the plan, it is best to work from larger areas of the drawing to more detailed features.

Long-sections and sectional elevations should be drawn in a similar manner to cross-sections. If the set of drawings includes cross-sections, drawing these first will make the long-section easie,r as vertical relationships will have been clarified before work starts on the more complex relationships of spaces and partitions that make long-sections more difficult to draw. It is useful to treat each compartment in turn so that features can be checked for changes of alignment. Variations in the height of purlins, tie beams, wall plates and floor levels may be symptomatic of structural changes and are important to represent as accurately as possible.

## Box 6: Drawing a cross-section

Most section drawings can be constructed from simple grids derived from the measurements taken on site of components within the building. A clearly defined starting point is the key feature. It is better to use a number of 'local grids' than to cover the drawing sheet with a large number of points measured in the horizontal and vertical axes. Different colours are used throughout the following example to help make these grids clear.

### Getting started

**Figure B6.1** As the focus of the sample drawing is a roof truss, work begins on the upper floor of the building.

- Draw a line representing the floor or horizontal datum.

- Height measurements can be drawn in either direction from this; in this example they are upwards for the roof truss.

- Draw a vertical line representing the wall. Measurements across the drawing will start from this.

- Draw in the grid marking the measured points to scale.

**Figure B6.2** Joining the points of the grid will establish the component, in this example the tie beam. While drawing a complex shape like this it is recommended that the site sketch and photographic reference are checked to ensure that the shape is correct.

B6.1

B6.2

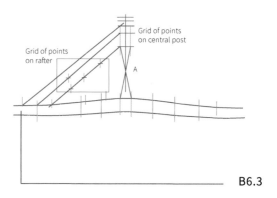

B6.3

B6.4

## Creating the overall shape of the roof truss

**Figure B6.3** Further grids are added to position the next components of the truss.

■ Measuring points on the central post will give the position of the top and bottom of the sloping rafter

■ Marking other points along the length of the rafter will confirm these are correct. Adjustments may be needed to compensate for any smalls errors in the on-site measurements prior to the lines being drawn in fully

■ The grid for the central post can be used to locate the centre line of the truss graphically (A) by drawing diagonals from upper to lower corner grid points. This is a useful check of the measurements at an early stage of the drawing, when adjustments are easier to make

**Figure B6.4** The main truss components are completed with a small number of grid points.

## Adding details

**Figure B6.5** With main components of the truss in place, details can be added to the drawing. The addition of these details may lead to minor adjustments of the drawing, but most will be adding to grid points already established. Placing components like purlins can require a new grid, as shown in the enlarged detail. Four key points are needed:

■ the upper edge that supports the common rafter (A)

■ the point at which the purlin meets the principal rafter (B)

■ The lower edge of the purlin (C)

■ The further lower edge of the purlin (D)

It is advisable to work out the positions of features like this before drawing in the other details, to avoid having to redraw if amendments are necessary.

**Figure B6.6** Further details can be measured in to complete the drawing of visible structural elements. In the example shown, this includes marking in the lower floor because this was visible on one side of the section.

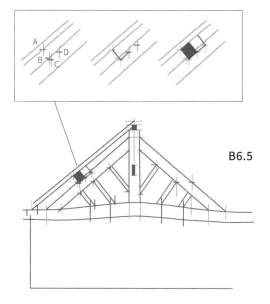

B6.5

B6.6

Measurements through the floor

Line of lower floor

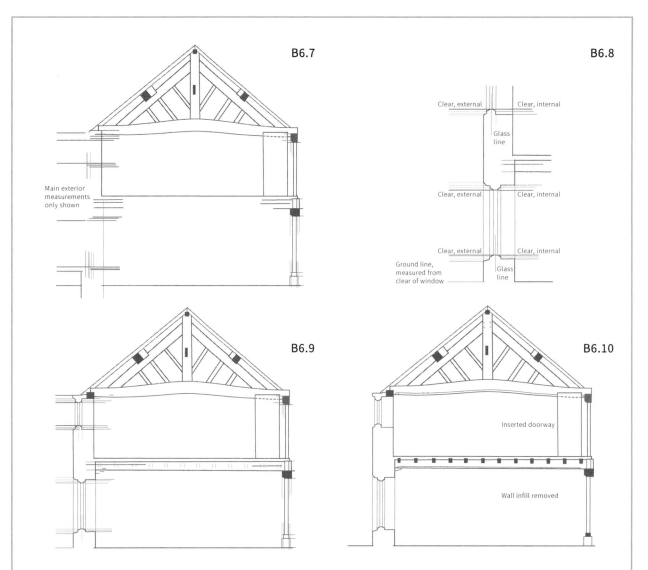

**Figure B6.7** Horizontal measurements from the plan can be added to begin marking in the details of the lower floor. Once this work is under way it is a good idea to mark in some of the measurements that will tie the two storeys together on the other side of the building. External measurements are shown in blue.

**Figure B6.8** A detail showing the matching of internal and external measurements to establish the thickness of the floor and ceiling. This is particularly useful when there is no direct access between the floors.

- Use points that are clearly visible to inside and outside;

- these can include window sills or lintels on both floors

- For the wall thickness, use the glass line of the window (as with drawing plans)

**Figure B6.9** Continue adding details to complete the drawing. At this stage some cleaning up of the draft is advisable, for example removing some of the construction marks and introducing some of the drawing conventions prior to making a finished version of the drawing.

**Figure B6.10** The completed draft. Annotation is useful to clarify certain features; some of this may be retained in the finished drawing, while some may be replaced by drawn conventions.

## 3.9  Drawing structural details

Often the clearest way of showing structural elements such as timber framing is to use site sketches with the minimum of reworking, with some annotation to aid understanding of the structure. When joints are to be used as a means of dating, however, it is advisable to draw them to scale so that they can be compared with other dated examples with more certainty. Views of the front, and either the top or bottom, are the most informative depending on accessibility in the field. Isometric or axonometric views can be used to combine these into a single drawing. Structural details often become clearer through use of exploded views, these having the advantage of showing very clearly how the components fit together. Commonly used scales for constructional details are 1:20 and 1:10. A simple grid is the easiest method to use for drawing up a timber joint, as it is for section and mouldings drawings.

## Box 7: Drawing a timber frame joint

**Drawing a timber frame joint using two views**
Simple grids, derived from the feature being drawn, provide a quick way of drawing joints in a timber frame using a side view and a top or underside view.

**Figure B7.1** The grid, starting at A for length measurements, shown in red, and B for vertical measurements, shown in blue. Some measurements are easier to add in the opposite direction, as on site, as shown in purple at C.

**Figure B7.2** The points marked on the grid are joined together.  The broken lines show parts of the joint visible from above and below which can be included if space restrictions prevent the two views from being used in the final drawing.

**Figure B7.3** The top view is drawn by extending the length grid marks downwards (D). Measurements across the feature are then added to form a new grid (E), shown in green.

**Figure B7.4** The completed drawing. A part of the joint not visible in the top view is still shown but in a broken line. This should be annotated.

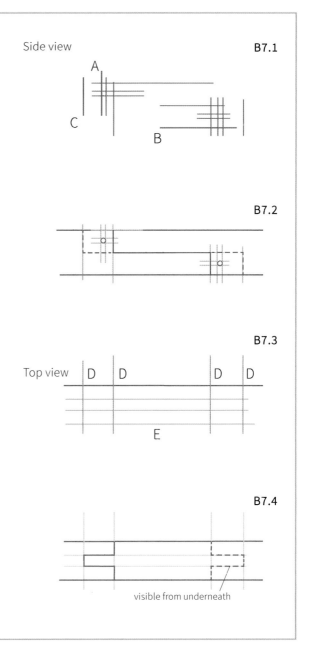

60

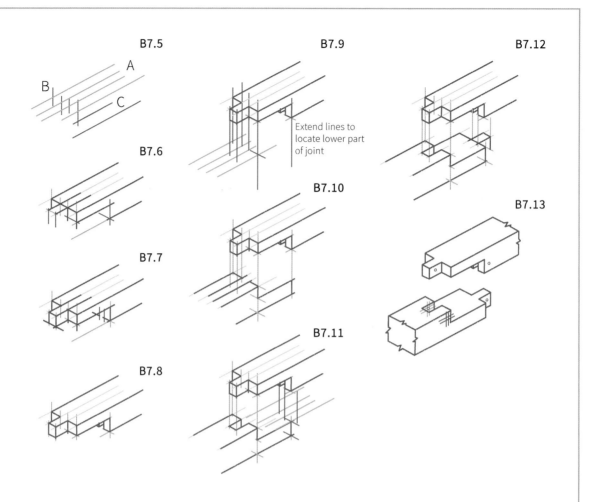

B7.5

B7.6

B7.7

B7.8

B7.9

Extend lines to
locate lower part
of joint

B7.10

B7.11

B7.12

B7.13

**Drawing a timber frame joint in isometric projection**

Both side and top views can be combined in a single drawing. Isometric projections can be drawn to scale, using a similar grid to simple side and top views. Drawing an exploded view shows more of the joint and how it works than an assembled view.

**Figure B7.5** The grid for the upper part of the joint is constructed first, using measurements taken on site. The measurements across the feature are marked lightly in pencil using an adjustable set square, or grey lines with CAD (A, in green), with marks added to set out length measurements (B, in red) and key vertical measurements (C, in blue).

**Figure B7.6-8** Points are joined together to draw the parts of the upper section of the joint, grid marks being added for each new component.

**Figure B7.9** On completion of the upper segment, the joint lines are extended to set out those parts that would be in contact with the lower portion of the joint. These are then used to start a new grid for the rest of the drawing.

**Figure B7.10-12** Each component is constructed by setting up more grids to complete the drawing.

**Figure B7.13** Details are measured in to complete the drawing. To make it clear that the timber is being shown in section, cut through marks can be drawn in.

## 3.10 The finished drawings

Once the draft drawings have been checked, to ensure that everything that needs to be shown has been drawn correctly, a final draft can be made. This applies to both hand-drawn surveys and surveys carried out with CAD. Producing a finished drawing that is clearly distinguished as such allows the draft to retain information that is important for the drafting process but might detract from the clarity of the finished drawing. This includes construction marks used in the drawing up, notes that might help the process of measuring, and so on. It is useful to keep this information in case amendments are needed at a later date. A finished drawing, or part of a drawing, might also become part of an illustration for a report or alongside several other drawings.

For hand-drawn surveys, producing the finished drawing usually means redrawing in a more permanent media than used for the draft, for example pen and ink rather than pencil. Despite advances in copying drawings using digital technologies, ink drawings still reproduce more easily than pencil ones and tend to be easier to read, leading to greater clarity. For long-term storage in an archive a dimensionally stable material such as polyester drafting film is recommended in preference to paper. A set of prints should also be made from CAD drawings, again using dimensionally stable materials, for long-term storage. For a drawing produced with CAD, further work is often needed to convert the working drawing into an illustration that can be used in a report or publication; this often requires the use of an additional piece of software, for example a graphics package.

## 3.11 Drawing conventions

It is recommended that the conventions shown in Appendix 1 are used to finish the drawings. These have been developed for illustrating historic buildings, and are now established and widely understood after being used for many years. Line weights should be appropriate for the scale of the drawing. Wall thicknesses will differ considerably, but thicker lines should be used to denote the main features, such as walls, on the cut line of the drawing, with lighter lines used to show features that lie below the cut line, for example the line of a window sill or plinth. This applies to sectional elevations as well, for example the edges of window or door openings, the line weights giving depth to the drawing and adding clarity. Elements behind the cut line, for example overhead details such as doorways and beams when looking down, should be shown in a dashed line.

The drawing should also have the following basic information marked on it permanently (Figure 16):

■ a title, for example, 'Ground-floor plan' or 'Section A-A1'

■ the name and address of the building, including the county, parish and street name and street number

■ an Ordnance Survey (OS) grid reference (NGR)

■ the name of the organisation and  individual responsible for the drawing

■ drawn metric and imperial scales rather than a stated scale for example 1:50 to avoid confusion when the drawing is reduced in size for publication

■ a grid north point on all plans, appropriately labelled if approximate

■ some indication of where a drawing fits within a set of drawings

In addition, to make all drawn surveys consistent and therefore easier to use, there are some general layout considerations to bear in mind:

- plans of single buildings should place the principal entrance to the bottom, except for plans of churches, which should be orientated conventionally with east either to the right or to the top

- plans of building complexes should place grid north to the top

All sections should give directional indications, with the location of the section shown on the plan, for example A–A1, B–B1. When sections or elevations are not accompanied by a plan they should be titled more fully.

## 3.12 Integrating hand-drawn and digital surveys

Hand-drawn and measured surveys of parts of buildings can be readily integrated into TST surveys. This offers a high degree of accuracy, as the digital survey will provide a reliable framework for the hand-measured parts of the survey to be fitted into. The most common way of doing this is to generate a framework of the exterior of the building, where possible adding some digital data to key internal areas to help tie the two sources of data together. The hand-measured elements can then be either drawn in using a CAD package or the framework can be plotted at an agreed scale, usually the scale at which the drawing is to be made, and the drawing completed as described for a wholly hand-drafted drawing. The digital drawing should give starting points for features, such as the beginning of window openings, doorways and so on. Combining surveys in this way can be especially useful when time is restricted on site or when survey equipment cannot be physically accommodated in restricted spaces in the building.

| Low Park<br>Alston Moor,<br>Alston,<br>Cumbria | NGR: NY 70956 46592<br>Surveyed by ATA, LAJ, MW Sept 2010<br>Drawn: ATA, March-April 2011<br>Sheet 1 of 2. |  |

| 2 Waterside<br>Ely, Cambridgeshire | NGR: TL 54492 80145<br>Surveyed: October 2014<br>Drawn by A T Adams | 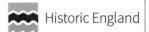 |

**Figure 16**
Two sample information boxes from English Heritage and Historic England recording drawing sheets.

# Case Study 3

## Nappa Hall, Askrigg, North Yorkshire

### Introduction

Nappa Hall is a late 15th-century manor house with a fortified appearance, with views up, down and across Wensleydale. It has a tower at both upper and lower ends of the hall and an attached service wing. A preliminary assessment of the building and detailed analysis of the associated earthworks were undertaken to inform proposals for its refurbishment and beneficial reuse in order to remove it from the Historic England Heritage At Risk Register. This was followed by a detailed analytical survey of the tower at the lower end of the hall block and attached service range, as the two ranges are awkwardly aligned and there is some debate about the chronology of the building and the possible original function of the service range (Figure CS3.1).

### Survey method

A TST survey was undertaken to create an outline plan of the hall, service range and

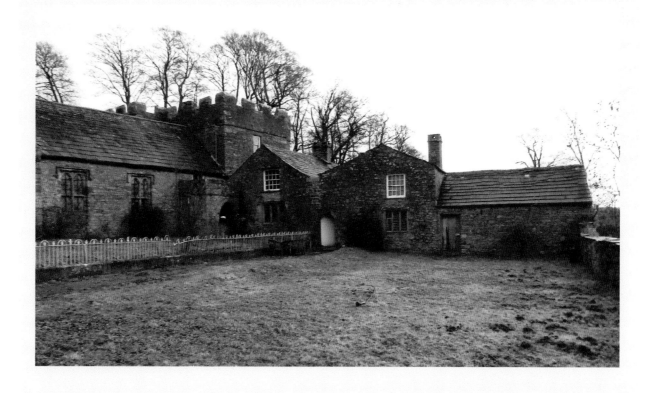

**Figure CS3.1**
The tower and attached service range at the lower end of Nappa Hall, Askrigg, North Yorkshire.

Part of the total station survey plot of the service range. This was used to underpin the draft pencil drawing derived from the hand-measured survey.

The additional survey points corresponding to the hand-measured survey are shown in green.

A: Narrow room inaccessible to TST
B: The workshop

**Figure CS3.2**

adjacent agricultural buildings, built as a stable range in the 18th century to serve the hall when it was made into a hunting lodge and later converted to farm buildings. The plan accurately located the buildings in relation to a previous archaeological survey of associated landscape features. A number of station points were also surveyed into the service range and lower end tower of the hall range (Figure CS3.2). These provided an accurate framework for a hand-drawn and measured survey of the same areas (Figure CS3.3). Some parts of the building in this area were inaccessible to the TST, being too narrow to accommodate the instrument and tripod (Figure CS3.4).

## Conclusion
The combination of TST and hand-measuring provided the most efficient and highly accurate means of surveying a challenging site in a limited time frame. A number of irregularities in the walls were recorded by the TST that may not have been picked out by hand taping alone, but similar irregularities were successfully recorded by both techniques and were found to overlay each other very accurately. The hand-measured survey also provided a training opportunity for a work placement with limited experience of measuring such sites (Figure CS3.5).

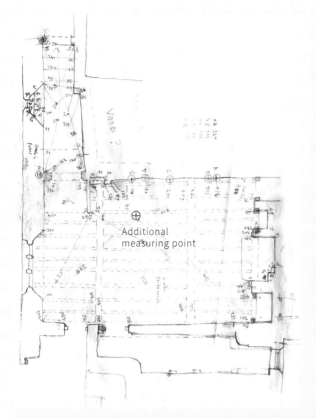

**Figure CS3.3 (top left)**
Detail of the site sketch used for the hand-measured survey. Additional triangulation points, in the green circles, were marked on an irregular wall adjoining the tower, measured from an extra survey point fixed to the room corners by diagonal measurements. These points were also captured with a TST.

**Figures CS3.4a (top right) and CS3.4b (bottom)**
A very narrow room that was inaccessible to the TST had to be measured by hand (a). Clutter in the workshop area also presented problems for the TST, especially as there was limited time on site (b).

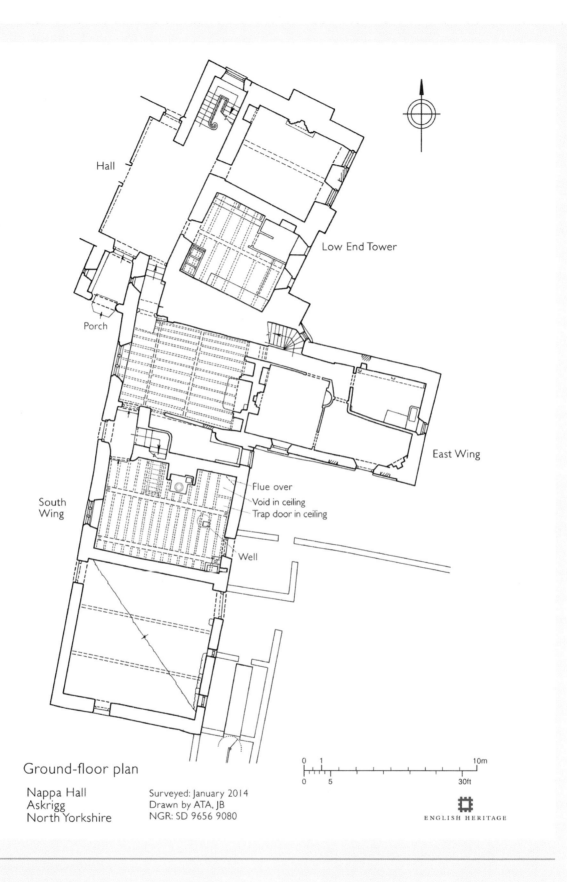

Hall

Low End Tower

Porch

East Wing

South
Wing

Flue over
Void in ceiling
Trap door in ceiling

Well

Ground-floor plan

Nappa Hall
Askrigg
North Yorkshire

Surveyed: January 2014
Drawn by ATA, JB
NGR: SD 9656 9080

0    1                               10m
0    5                          30ft

ENGLISH HERITAGE

**Figure CS3.5**
The completed record plan showing the ground floor
of the service range and lower end tower of Nappa Hall.

# 4 Bird's-Eye Views, 3D Drawings and Reconstructions

## 4.1  Introduction

The understanding of historic buildings can be made easier by drawings that engage the viewer. Bird's-eye views or other types of 3-dimensional (3D) drawings do this in a way which the 2D drawings described so far cannot do. Such drawings are particularly effective for showing:

- the relationship of several buildings of different heights and forms in a complex, for example the buildings of a farmstead or industrial site

- more than one elevation in a single drawing, particularly when the building has a complex form, for example projecting wings, or when particular functional aspects are being illustrated

- the form of complicated timber framing joints or other structural elements that are not easily explained by a single drawing or clearly shown in photographs

- information in a way that is understood by non-specialists, broadening the audience for the work

Such drawings entail some additional work in the field in order to ensure that the relevant views are sketched and a small number of extra measurements collected, in addition to those needed to prepare plans, sections and elevations. Site sketches of framing joints and other structures can also be used with little additional work (Figure 17). Annotation, which relies on a more in-depth understanding of the subject being drawn derived from a wider study of published examples, makes such sketches more useful.

**Figure 17**
The site sketch of part of the attic of 22, 24 High Street, Ely, Cambridgeshire, was used in a report with minimal alteration. The aim was to focus attention on the detail of an earlier ceiling joist underneath the later roof truss, which was less clear in photographs. Recording for the Early Fabric in Historic Towns: Ely project (RRS 2-2016 forthcoming).

Perspective drawings are probably the most easily understood form of 3D drawing but, apart from drawings worked up from site sketches, are not necessarily the best types of drawing for recording purposes. Showing buildings in perspective means that they are drawn with a diminishing scale and setting up perspectives can be difficult and time consuming, especially for the inexperienced.

A number of parallel projection drawing types can be employed to give 3D views similar to perspectives. These are measurable projections, so key elements, such as plans, sections and elevations, are drawn to accurate scale values and are combined with measured vertical axes in the drawing. They are relatively straight forward and less demanding to produce than perspective views. Printed isometric grid pads are available and many CAD packages have built in isometric drawing functions.

Three-dimensional drawings of this kind can also be developed as reconstruction drawings and cutaway views. In the latter some of the walls, roof covering and floors are removed to reveal interior details in the same drawing as exterior details. This can be useful for showing relationships between numerous floor levels and relating interior spaces to exterior features. These types of drawing are more often used to illustrate publications and exhibitions that are produced after the original reports have been completed, and are aimed at a wider audience but, like reconstruction drawings, they are also a useful aid to interpreting the evolution of a building (Figure 18).

Using drawings to disassemble parts of a building visually, while showing the assembled parts alongside, is also possible using this form of drawing, although they require some additional research to ensure they are correct. Computer modelling can be used to generate such models, but this tends to require more training and experience on the part of the practitioner and more time to create the model.

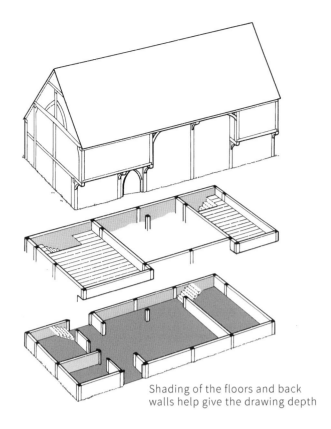

Shading of the floors and back walls help give the drawing depth

**Figure 18**
Simple cutaway drawings consisting of plans drawn in isometric projection with the walls extended upwards and one floor above the other, clearly show circulation within the building. A simplified reconstruction of the exterior can be built up rapidly from such projected plans, most of the height measurements having been taken for section drawings. *See* Barnwell and Adams, 1994 *The House Within: Interpreting Medieval Houses in Kent.*

## 4.2 Types of drawing useful for recording buildings

### Site sketches of construction details
In addition to site sketches of plans and sections, which are used as the basis for noting measurements for later drawing up, site sketches can be used as an additional aid for noting elements that do not photograph well. The act of drawing reinforces what is seen and understood on site. Sometimes these sketches can be used with little additional work to clarify and shorten written descriptions that might otherwise be lengthy. They are particularly suited to illustrating structural elements, such as timber framing and changes in masonry (Figure 19).

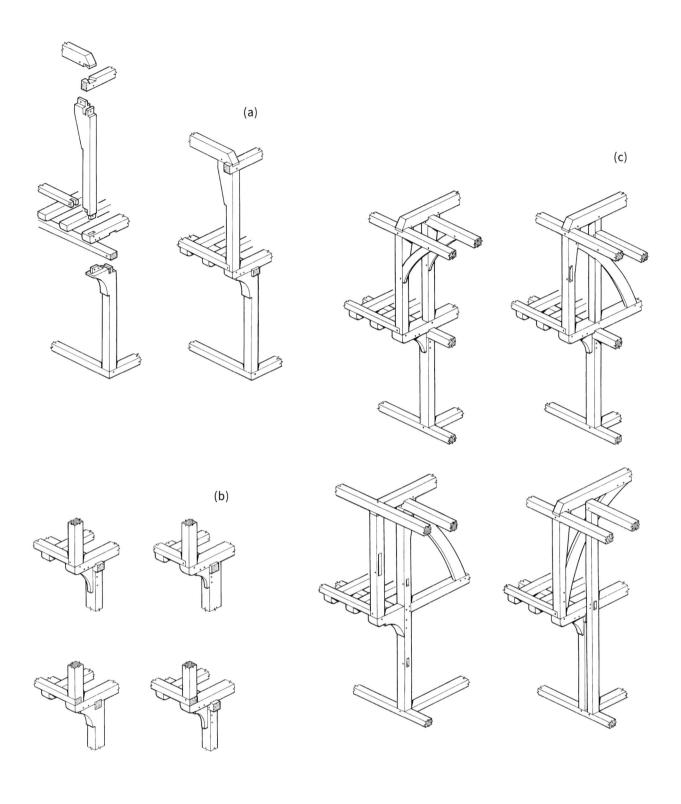

(a)

(b)

(c)

**Figure 19**

Sketching timber frame detail is a useful analytical tool that can provide insight into how the frame was made. Sketches can also be used when framing is difficult to photograph, for example because of black paint. When redrawn afterwards, sketches, incorporating information from interior and exterior site sketches and from photographs, can be used for a number of illustrations, including views of how the various components fit together (a). Using the same projection allows comparative diagrams to be drawn (b and c) while concentrating on the main structural elements. *See* Barnwell and Adams, 1994 *The House Within: Interpreting Medieval Houses in Kent*.

## Moulding details

Mouldings are usually drawn as a section through the profile or as an elevation of the moulded timber or stone. It is sometimes useful to sketch the termination of the moulded element or use a parallel projection to extend the decoration, to give a 3D effect. A few extra measurements are needed on site to facilitate this, although unmeasured sketches can be used alongside measured profiles (Figure 20).

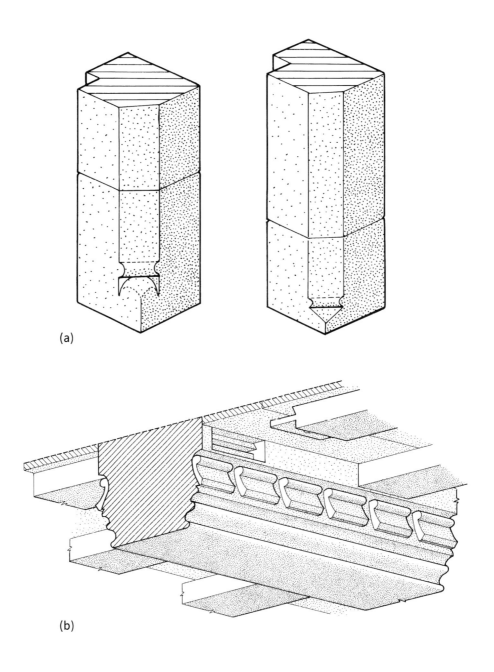

(a)

(b)

**Figure 20**
Three-dimensional views of mouldings can be made from site sketches without measurement (a). Drawings bring such details more sharply into focus than a photograph. Measured drawings, especially moulding profiles, can also be enhanced by drawing in isometric projection (b). (see also Box 2 and Barnwell and Giles, 1997 *English Farmsteads 1750-1914*).

## Bird's-eye views

A single drawing that shows two sides of a building at once can make the building more easily understood and save space in the report. Additional information is often also included, for example an outline of the roof, as well as information usually shown on a plan. It is important to consider whether this type of drawing will be used when doing the fieldwork, to ensure that the additional measurements required are taken on site. This may only be a small number if a set of drawings, including a plan and some sections, are also being drawn.

**Site sketches**

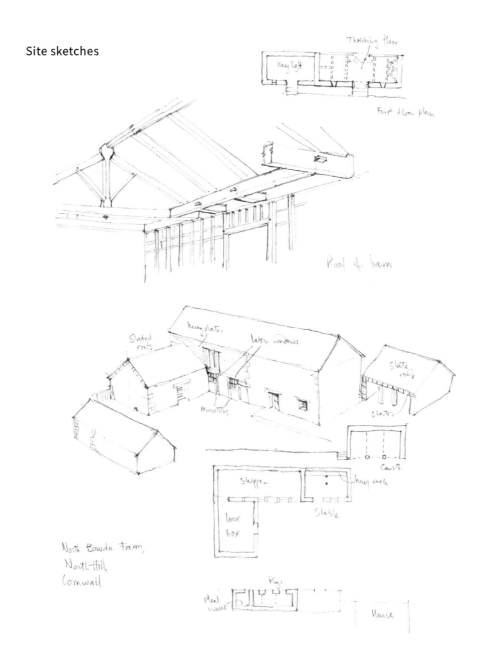

**Figure 21a**

Bird's-eye views give a clear impression of the relative heights and overall arrangement of groups of buildings. For simple groups, like a farmstead, they can be quickly sketched on site and act as an additional visual note.

Few additional measurements are needed if other detailed drawings, such as plans and sections, are made of the site.

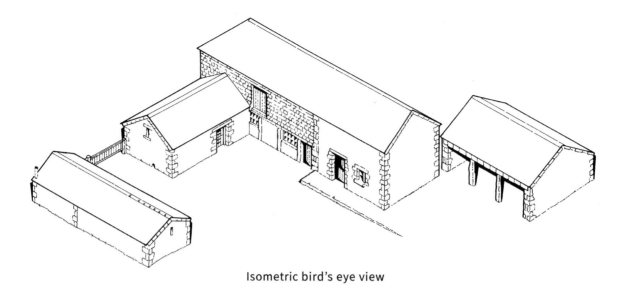

Isometric bird's eye view

**Figure 21b**
The bird's-eye view, a measurable isometric projection,
is part of a set of drawings that includes a site plan,
ground-floor plan and sections of the barn.

Bird's-eye views are particularly useful for small complexes of buildings in which there are structures of various forms, heights and functions which often take advantage of varying ground levels. An example would be a farmstead with a two-storey barn serving single-storey animal sheds (Figures 21a and 21b). Although photography records these differences very well, a drawing can convey information about the various component parts in a single image, thus enhancing understanding about the site. Decisions taken on site about viewpoints and the point of interest of the drawing will determine the measurements needed to complete the drawing. It may be necessary to obtain some height measurements inside the buildings, but these can be added quickly to outline sketch sections if fully measured sections are not drawn.

## 4.3 Reconstruction drawings

Reconstruction drawings show buildings, or parts of buildings, as they appeared before later modifications changed their appearance or use. They can range from sketches of modified timber joints or mouldings to complete buildings. The modified or missing components are typically recreated in drawn form by incorporating information about the missing elements from research on other buildings with similar characteristics, or from documents, such as historic views, written accounts, archaeological evidence and map evidence (Figure 22). Because they draw on so many diverse sources of information they are a powerful tool in understanding how a building has evolved and although they are often used to illustrate books and other forms of publication, their value during the recording of buildings, visually testing the evidence and suggesting new lines of enquiry, should not be underestimated. The type of drawing used can range from a simple block plan, reconstructed sections and elevations to complex cutaway views, depending on why they are being made.

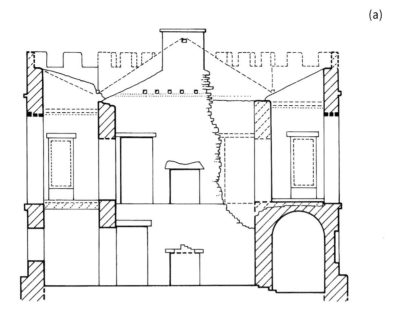

(a)

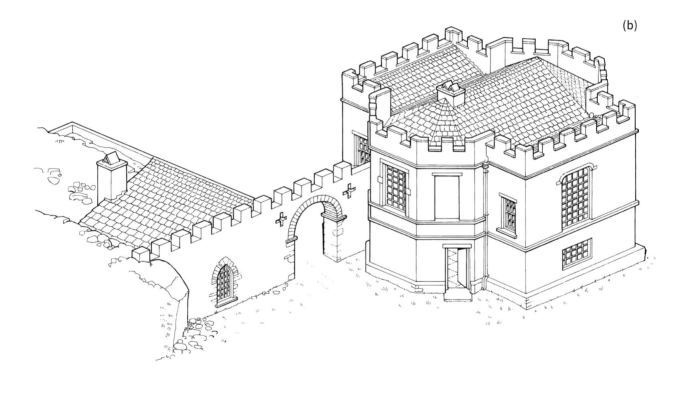

(b)

**Figure 22**

Reconstruction drawings can include plans and sections (a). When drawn as part of a record the reconstructed elements should be clearly differentiated with a different line style or labelling. A bird's-eye view (b) gives a good overall impression of more than one building on a site.

This type of drawing combines information from sections, plans and elevations to show the connections between structural elements that would otherwise only be visible in a number of illustrations. Both perspective and parallel projections can be used, the latter being the quicker and easier method and retaining a degree of measurability. A good grasp of the structure of the building being drawn is needed to make the drawing convincing, although detail can be simplified if this helps clarify what is being illustrated. Such drawings are usually used for illustrating publications aimed at a wider audience than that of a report (Figure 23).

## 4.4 Drawing media

Most of the 3D drawings described can be made using the same media, CAD, pencil or pen and ink, as the other drawings made for a report. Tone and colour can greatly improve the effectiveness of a cutaway or other drawing that shows multiple

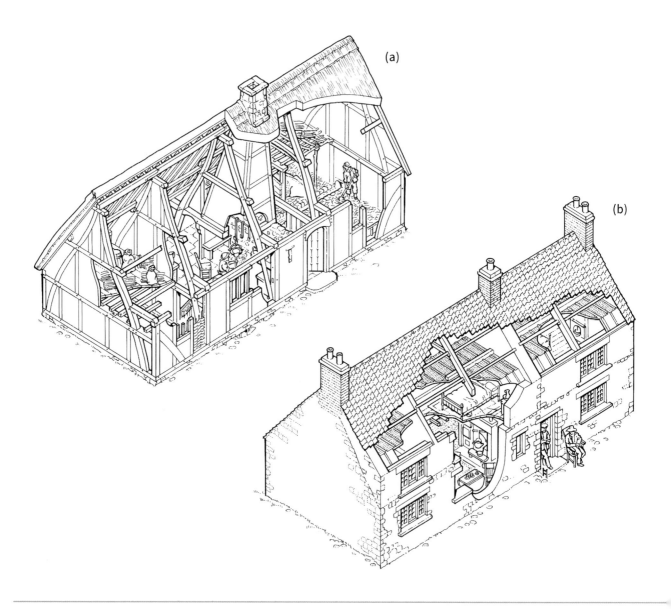

(a)

(b)

**Figure 23**
Reconstructed cutaway views can be used to show parts of both the interior and exterior of buildings in a single drawing. Incorporating elements of plans, sections and elevations, they are difficult and time consuming to construct. However they can be used, with the addition of furniture and other fittings, to bring buildings back to life. Additional research is necessary to ensure that the details are correct. They are most often used to illustrate books and exhibitions rather than recording projects, but can be a useful

floors or combines a number of sections or other surfaces. It is good practice to use a combination of thick and thin lines, to give an impression of depth or separate one component from another, rather than use a single line weight.

The impact of a cutaway drawing is enhanced by applying a tone to the horizontal surfaces, such as floors and ceilings, which emphasises vertical walls. This can be drawn onto the original pencil or pen drawing or can be added as a flat tone using a graphics computer program after scanning. If CAD is used for the drawing, various means of adding tone can be found within the software or fully rendered images can be made, some involving the use of photographic imagery to apply surface finishes. Full-colour illustrations might be appropriate for wider distributions through publications or exhibition work, although the creation of this type of image can be time consuming and costly.

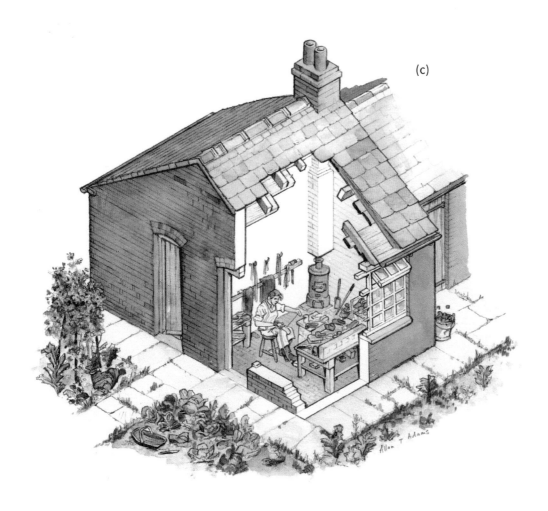

(c)

analytical tool. Typical uses are to show how a building has changed over time, for example the evolution of a 16th-century longhouse in Helmsley, North Yorkshire (a) into a 19th-century farmhouse (b). Such drawings can be made more appealing to non-specialist audiences by the addition of colour (c). *See* Morrison and Bond, 2004 *Built to Last? The Buildings of the Northamptonshire Boot and Shoe Industry.*

# Case Study 4

## Old Manor House, Manningham, Bradford

### Introduction

The Old Manor House, Manningham, probably originated in the early16th century as a hall-and-crosswing timber-framed house (Figure CS4.1). It was modified a number of times, being encased in stone on a hall-and-crosswings plan in the 17th century, and in the 19th century was first subdivided and later truncated as rural Manningham became a suburb of Bradford. The building was surveyed for a number of reasons.

- The listed building was on the English Heritage (now Historic England) Heritage At Risk register because of a long period of neglect and a number of failed attempts at redevelopment. Information was therefore critical for its long-term management

**Figure CS4.1a**
The front of the building (a). Part of the roof had been removed, causing damage to floors and ceilings, and then replaced with plastic sheeting.

- It was part of a study of the character and diversity of the suburb of Manningham, which would result in a book about how Manningham has adapted to change, aimed at a wide audience

- The study had identified the building as probably the oldest domestic building in the township so would certainly feature in the book and would require some form of illustration

### Survey method

The survey was conducted initially by members of the English Heritage Assessment Team. As the significance of its probable early date came to light, more detailed analytical drawings were undertaken to enable production of a more comprehensive report and to provide data for a range of other illustrations. The building's compact size and relatively complex evolution also made it a useful site for training a work placement in field survey and report writing.

It was drawn and measured by hand, much of the evidence being difficult to access using a TST or of a nature that was better measured with hand-held measuring instruments, for example the 17th-century window frame mouldings (Figure CS4.1(b)). A range of drawings were produced from the survey:

- a plan and two sections, drawn at 1:50 scale, that were reproduced in the report (Figure CS4.2)

- a series of isometric drawings showing the building at three important stages of its development (Figure CS4.3)

**Figure CS4.1b**
Shows part of the ground floor area inside, with a large pile of rubble. See **RRS 14-2012**

- a reconstructed long-section and cutaway view to aid understanding of the building for the work placement writing the report. (The cutaway view was also used to illustrate the report).

- Full-colour illustrations, including plans, building for use in the book *Manningham: Character and diversity in a Bradford suburb* (Taylor and Gibson 2010) (Figure CS4.4)

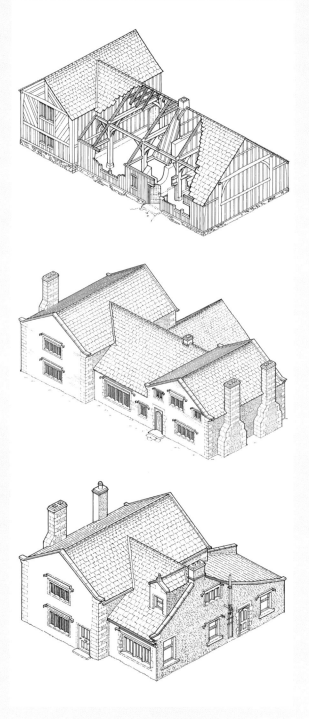

(a)

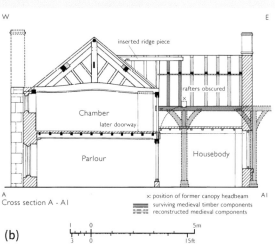

(b)

**Figure CS4.2**
The cross section of Old Manor House. (a) shows the field sketch and (b) the finished record drawing.

**Figure CS4.3**
Isometric drawings charting the main phases of the building's development. There is evidence for the 16th century aisled hall and probable crosswing. The hall was encased in stone and new crosswings built in the 17th century. In the late 19th century the building was truncated by road widening as Manningham became a suburb of Bradford. See RRS 14-2012

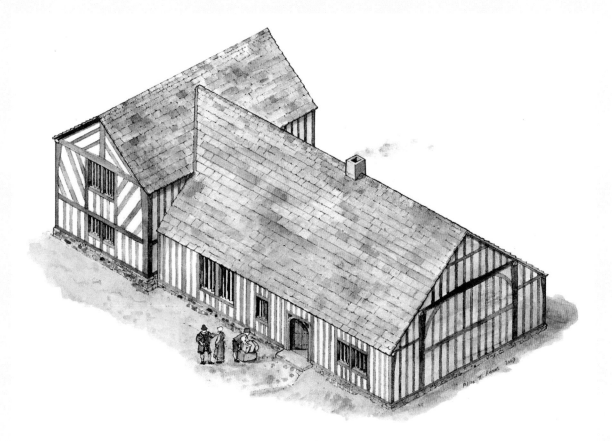

**Figure CS4.4**
A reconstruction drawing of the phase I building was rendered in watercolour for publication in a book aimed at a none-specialist readership. See

Taylor and Gibson, 2010 *Manningham: Character and Diversity in a Bradford Suburb*.

## Conclusion

The employment of hand drawing and measuring on site provided the data needed to interpret fully a small but complex building. Conditions inside the building, including piles of building rubble and otherwise obscured sight lines, precluded the use of some digital survey equipment, while the close examination of the fabric needed to obtain the measurements by hand also helped reveal details that may otherwise have been missed. The field survey provided the basis for making a series of illustrations that greatly enhanced the understanding of the building by allowing comparison with other known examples of similarly fragmentary survivals of early building fabric.

# 5 Completing the Drawing

A finished drawing is seldom the end of the process of making a drawn record or illustration. The addition of annotation will greatly enhance the understanding imparted by analytical record drawing. Whether the drawing is made by hand or by computer there is usually a final, computer-based stage, to complete the record so that the drawing can be shared with others and the drawn record or architectural illustration, integrated with written accounts, photographs and other forms of illustration, for example historic images including engravings and photographs.

## 5.1 Annotation

Clear annotation can greatly improve the amount of information provided by an illustration. Captions can supply much of this additional information but combining image and word together can be a powerful tool. Labels can be used to:

■ provide information that clearly states the orientation of the building or the particular view in the drawing

■ clarify the part or parts of the building being illustrated

■ allow better cross-referencing between drawings in a set

■ identify separate components, for example the individual parts of a framing joint

■ differentiate reconstructed elements from surviving elements

The addition of such labels can be a useful tool throughout the process of making the drawings. It is particularly important when making the initial site sketches, clearly identifying items of significance that need measuring and prompting other actions, such as photography. During the drawing up, labels can be used to identify areas of the drawing that need further consideration from others working on the building.

Drawings made by computer can be readily labelled as work progresses. When drawing by hand there are number of methods that can be used to add annotation. Whichever method is used a number of key points should be borne in mind. The lettering should always:

■ clear and easy to read

■ use a hierarchy of sizes consistently, for example to separate titles from detailed labels

■ be kept in proportion to the drawing

■ be concise

Any annotation from other recorders or authors requiring changes to the drawings should also be made clear.

## 5.2 Annotating by hand

Few people have the skill to write labels clearly using their day to day handwriting. Adding lettering to finished drawings therefore requires some training, especially when using technical drawing pens that are designed to be used with drawing aids to produce precise line thicknesses. If annotation has to be applied to pen-and-ink drawings by hand, neater lettering can be achieved by using lightly pencilled lines to set out the top and bottom of the lettering. Neat work can also be produced if the drawing is done on tracing paper or tracing film by placing graph paper beneath the drawing sheet. Proportion is important when lettering, a useful guide being that 2mm high lettering should be drawn with a 0.2mm or 0.25mm pen, 3mm lettering with a 0.35mm pen and so on. The lettering height should also be in proportion to the drawing it annotates, allowing the drawing to work without having to compete with the lettering for attention.

Hand-drawn lettering can also be applied with stencils although these may be difficult to obtain as they have largely been superseded by computers. Stencils work to similar proportions as those recommended for hand-drawn lettering, the most useful for labelling drawings being 3.5mm high for use with 0.35mm pens. Larger, for example 5mm stencils, can be used for titles.

Rub-down lettering such as Letraset ® is not recommended for drawings intended for long-term archival storage. In addition to being difficult to obtain now, because of the use of computers, the adhesive has a relatively short life so the annotation will probably become detached over time.

## 5.3 Computer finishing

The most common method for finishing record drawings made by hand is to use a computer. This has several advantages:

- drawings can be more easily integrated with other elements of the record, such as text and photography

- computer applied annotation give drawings a more professional-looking appearance

- labels can be more easily edited, moved from one part of the drawing to another or removed

The use of computers is of utmost importance for the distribution of finished drawings, whether as a component in a report, via computer file sharing or publishing in various forms, such as on the World Wide Web and as traditional books.

The way in which some CAD software works makes it advisable to import digital drawings into graphics software for final finishing as there are differences in the way the software and hardware translates the data for long-term storage, display and printing purposes.

### Scanning

Hand-drawn records and illustrations can be digitised by taking a photograph with a digital camera, but far better results will be obtained by using a scanner. The most useful for drawings is a flatbed scanner as this will:

- provide a flat surface for the drawing

- provide greater control of the scanning compared with hand-held scanners, in particular for image resolution and scale

The widespread use of flatbed scanners has been an influential factor in the production of drawn artwork for publication for some years. A4- and A3-size scanners are available for use in homes and offices, while larger scanners are usually only found in specialist digital-

| Purpose of scan | Greyscale | Colour | Black and white |
|---|---|---|---|
| Printing on paper | 300dpi | 300dpi | 1200dpi |
| Publication (book) | 300-600dpi | 300-400dpi | 1200dpi |
| Publication (web) | 180-200dpi | 180-200dpi | 600-1200dpi |

**Table 2**
Scanning resolutions for different media.

image processing shops. This has often limited illustration artwork to A3 (420 x 297mm) size, with a consequent influence on the scale of record drawing; however, larger scans can be made quite cheaply at a copy bureau.

The quality of the digital copy is determined by the resolution of the scanned image. This is a description of the recorded light and dark shapes of the image, usually expressed in dots or pixels per inch (dpi/ppi) or centimetre. Better resolution is given by a higher density of dots. If necessary the scanned copy of the drawing can be improved, for example areas of detail can be amended to prevent filling-in when the drawing is reduced in size.

Table 2 lists scanning resolutions.

## Computer annotation
Once scanned, drawings can be imported into graphics software for finishing touches to be applied. The most important of these is likely to be the annotation, which will make the drawing more effective. As with lettering applied by hand this should be in proportion to the drawing or features within the drawing that need emphasising or explaining.

The use of computers also means that standardised north points and scale bars can be added more easily than when drawn by hand, as can tone and colour if these aid understanding.

## Printing
The convenience of storing and sharing digital drawing files makes them an ideal medium for creating records and ensuring that they reach the people that may need to use them. It is nevertheless a good idea to make one or more prints of such drawings. This makes it easier to check the work: often checking a paper print reveals minor errors more quickly than many checks of a computer screen.

'Hard copy' of record drawings may also outlive the digital storage and computer systems that were used to create the digital file, as systems are updated and/or replaced.

# 6 Conclusion

Drawing and measuring by hand remain useful tools for recording historic buildings. They are versatile methods, requiring close observation and physical contact with the subject, which can lead to additional discoveries and deepen understanding while conducting site work. They can also be combined with digital survey to produce highly accurate measured drawings. Used on their own, they can provide illustrative material ranging from basic block diagrams to full measured surveys with the accuracy necessary to support written accounts of building evolution. Drawings produced in this way can also be used as the basis for more accurate interpretive cutaway and reconstruction drawings.

# 7 References

Andrews, D, Bedford, J, Blake, B, Bryan, P, Cromwell, T and Lea, R 2010 *Measured and Drawn: Techniques and Understanding for the Metric Survey of Historic Buildings,* 2 edn. Swindon: English Heritage

Bedford, J, Pearson, T and Thomason, B 2015 *Traversing the Past: The Total Station Theodolite in Archaeological Landscape Survey.* Swindon: Historic England https://www.historicengland.org.uk/images-books/publications/traversingthepast/

Lane, R 2016 *Understanding Historic Buildings: A guide to good recording practice* Swindon, Historic England https://www.historicengland.org.uk/images-books/publications/understandinghistoricbuildings/

Smith, P 1975 *Houses of the Welsh countryside: A study in historical geography* London: Her Majesty's Stationery Office (HMSO)

Taylor, S and Gibson, K 2010 *Manningham: Character and diversity in a Bradford suburb* Swindon: English Heritage

## 7.1 Further reading

Barnwell, P S and Adams, A T 1994. *The House Within: Interpreting Medieval Houses in Kent.* London: HMSO

Barnwell, P S and Giles, C 1997 *English Farmsteads 1750–1914* Swindon: RCHME

Borden, A and Giles, C 2012 *The Old Manor House, Rosebery Road, Manningham, Bradford, West Yorkshire: An Historical and Architectural Survey.* Research Report Series no. 14-2012. Swindon: English Heritage http://research.historicengland.org.uk/Report.aspx?i=15088&ru=%2fResults.aspx%3fp%3d1%26n%3d10%26ry%3d2012%26a%3d4721%26ns%3d1

Howard, C 2015. *Hooton Park Aerodrome, Chester and Chester West: An Assessment of the General Service Sheds and Associated Buildings.* Research Report Series no. 76-2014. Swindon: English Heritage. http://research.historicengland.org.uk/Report.aspx?i=15309&ru=%2fResults.aspx%3fp%3d1%26n%3d10%26a%3d4792%26tsk%3dHooton%2520Park%26ns%3d1

Jessop, L, Whitfield, M with Davison, A, 2013 *Alston Moor, Cumbria: Buildings in a North Pennines Landscape.* Swindon: English Heritage

Morrison, K A with Bond, A 2004 *Built to last? The Buildings of the Northamptonshire Boot and Shoe Industry* London: English Heritage.

Taylor, S and Gibson, K, 2010. *Manningham: Character and Diversity in a Bradford Suburb.* Swindon, English Heritage.

## 7.2 Acknowledgements

Tim Richardson FSAI read and commented on an early draft of the document. Trevor Pearson and Jon Bedford made many helpful suggestions throughout the production of this guidance. Anna Bridson photographs of equipment and measuring on site.

# 8 Glossary

**Axonometric projection**
Is a type of parallel projection used for creating a drawing where the plan is drawn to scale but rotated at an angle of 60° or 30° along one or more of its axes relative to the normal axis.

**Bressumer**
Load bearing beams in a timber framed building, usually found over open spaces such a fireplaces and supporting he lower part of upper-storey walls in jetty construction.

**CAD computer-aided drawing/design**
A term used to describe graphics software packages usually used in engineering and design. As these disciplines require a high degree of precision, they are also ideal for survey applications.

**Crown-post**
Upright timber set on a tie-beam supporting the longitudinal timber beneath the collar beams of some medieval (14th–16th century) roofs.

**Collar beam**
A horizontal piece of timber connecting two rafters and forming with them an A-shaped roof truss. In crown-post roofs collar beams are supported by a collar purlin which is supported by the crown posts.

**Cutting plane**
The line of cut through the structure and spaces of a building, a horizontal cutting plane is used to produce a plan a vertical cutting plane is used to produce section drawings.

**Datum line**
A horizontal or vertical reference line used to control height and horizontal distance measurements.

**Isometric projection**
A drawing which creates a 3D effect by drawing a plan to scale but not at right angles, being set at 27°–30° to the horizontal and projecting the vertical axes to scale. The plan is slightly distorted but the effect is more realistic than in an axonometric projection.

**Jettying**
Is a medieval and early post-medieval building technique in which an upper floor projects beyond the dimensions of the floor below.

**Jetty bracket**
A supporting timber, usually curved, used to give added strength to jettied upper storeys in medieval buildings.

**Laser scanning**
Laser scanning is a method for the automated mass capture of 3-D points at fixed intervals. The scanner is used to create a 'point cloud' of the surface of the subject. These points can be used to recreate the shape of the subject.

**Mouldings**
Continuous projecting or inset architectural embellishment. Mouldings are used to enrich, emphasise and separate architectural components by casting shadows and otherwise making the item they form part of visually distinct from their surroundings. They are to be found on doorways, structural beams and other parts of buildings. Their distinctive style is often used as a means of dating the part of the building on which they are found.

**Orthographic projection**
Orthographic projection is means of representing a 3D object in two dimensions. This produces plans, sections and elevations depending on whether the chosen view is vertical (plans) or horizontal (sections) depending on the placement of the **cutting plane.** A viewpoint outside the building results in an elevation.

**Parallel projection**
Parallel projections have lines of projection that are parallel both in reality and in the projection plane

**Perspective**
Perspective is an approximate representation, on a flat surface, of an image as it is seen by the eye. The two most characteristic features of perspective are that objects are smaller as their distance from the observer increases

**Photogrammetry**
Photogrammetry is the production of accurate line drawings from overlapping, or stereo, photographs. The photographs replicate the view captured by each eye, giving a 3-D effect. Digital cameras and computer software are used to capture images and match pre-surveyed points to permit accurate scaling.

## Purlin

A horizontal beam along the length of a roof, supported by principal rafters or collar beams, and supporting the common rafters or boards.

## Rectified photography

A rectified photograph is one modified to remove distortions. This can be done through simple perspective correction using a tilt or shift lens or digitally by forcing lines that are vertical or parallel in the photograph to match those in the real world. Digital software can be applied to photography to create scalable images by matching points in the image to a set of 3-D coordinates.

## Scarf joint

A type of joint between two timbers meeting end-to-end and designed to appear as one continuous piece.

## Soffit

The underside of a beam, joist or arch.

## Tie beam

A horizontal beam connecting two rafters in a roof or roof truss.

## TST Total station theodolite

The theodolite is a tripod-mounted calibrated optical instrument used to measure horizontal and vertical angles in order to determine relative position. On a TST the angles and distance to surveyed points are recorded digitally, each point being located relative to the instrument. Digital data are passed to a computer with software that calculates the coordinates of each point and presents the survey as 2D or 3-D drawings.

# Appendix

## Drawing Conventions

### General

Detail on cutting plane

Detail beyond or below cutting plane

Former and conjectural line of building

Detail behind or above cutting plane

Centre line

Scale bar

(for small-scale drawings)

### Plans

#### Walls

Walls

Former walls

Wall with plinth

Wall of unknown thickness

#### Doors and windows, etc

| | Levels 1 and 2 | Levels 3 and 4 |
|---|---|---|
| External door with wood frame | | |
| External door with masonry jambs and step up | | |
| Internal door | | |
| Blocked doors (stippled or hatched), label bd | | |
| Window with sill and wood frame | | |
| Window with masonry jambs | | |
| Walk-in window | | |
| Walk-in window (no wall over) | | |

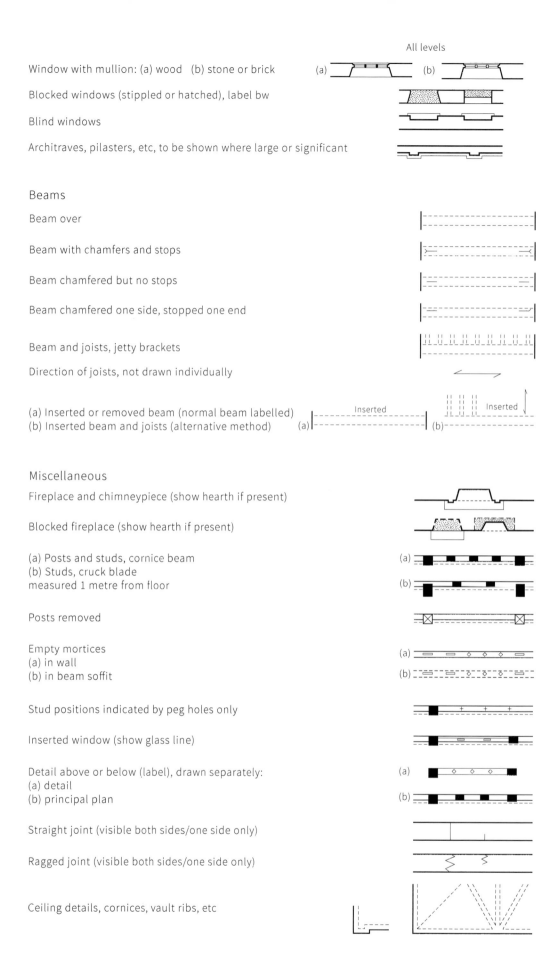

All levels

Window with mullion: (a) wood   (b) stone or brick

Blocked windows (stippled or hatched), label bw

Blind windows

Architraves, pilasters, etc, to be shown where large or significant

## Beams

Beam over

Beam with chamfers and stops

Beam chamfered but no stops

Beam chamfered one side, stopped one end

Beam and joists, jetty brackets

Direction of joists, not drawn individually

(a) Inserted or removed beam (normal beam labelled)
(b) Inserted beam and joists (alternative method)

## Miscellaneous

Fireplace and chimneypiece (show hearth if present)

Blocked fireplace (show hearth if present)

(a) Posts and studs, cornice beam
(b) Studs, cruck blade
measured 1 metre from floor

Posts removed

Empty mortices
(a) in wall
(b) in beam soffit

Stud positions indicated by peg holes only

Inserted window (show glass line)

Detail above or below (label), drawn separately:
(a) detail
(b) principal plan

Straight joint (visible both sides/one side only)

Ragged joint (visible both sides/one side only)

Ceiling details, cornices, vault ribs, etc

Stairs and steps (arrow pointing up, handrail conventionised) show scroll if applicable

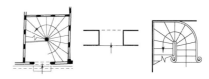

Stairwell: ground, intermediate, top

Cupboard above floor level

Cupboard at floor level (optional label)

Direction indicators for sections

## Industrial and mechanical

Box and centre line of surviving line shaft (drawn full extent)

Bearing box, direction of drive

Boxes over door and window

Trap in floor with upright shaft and direction of drive

Trap in ceiling with rope drive

Box transferring drive from flywheel, flywheel bearing box

Flat fireproof ceiling, beams and cast-iron columns

Arched jack vaulting, beams and removed columns

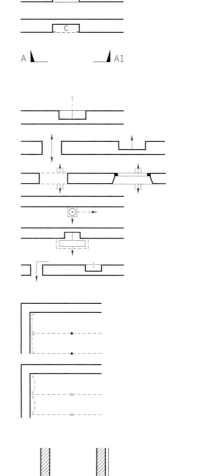

## Sections

Wall, wall and framing post

Beams and joists

Removed beam, removed joists

Inserted beam, inserted joists

Timber beam (when beams of different materials are in the section) and metal I beams

Timber framing (pegs and empty holes to be shown)

Removed framing

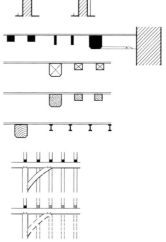

This page is left blank intentionally

# Contact Historic England

## East Midlands
2nd Floor, Windsor House
Cliftonville
Northampton NN1 5BE
Tel: 01604 735460
Email: eastmidlands@HistoricEngland.org.uk

## East of England
Brooklands
24 Brooklands Avenue
Cambridge CB2 8BU
Tel: 01223 582749
Email: eastofengland@HistoricEngland.org.uk

## Fort Cumberland
Fort Cumberland Road
Eastney
Portsmouth PO4 9LD
Tel: 023 9285 6704
Email: fort.cumberland@HistoricEngland.org.uk

## London
1 Waterhouse Square
138-142 Holborn
London EC1N 2ST
Tel: 020 7973 3700
Email: london@HistoricEngland.org.uk

## North East
Bessie Surtees House
41-44 Sandhill
Newcastle Upon Tyne
NE1 3JF
Tel: 0191 269 1255
Email: northeast@HistoricEngland.org.uk

## North West
3rd Floor, Canada House
3 Chepstow Street
Manchester M1 5FW
Tel: 0161 242 1416
Email: northwest@HistoricEngland.org.uk

## South East
Eastgate Court
195-205 High Street
Guildford GU1 3EH
Tel: 01483 252020
Email: southeast@HistoricEngland.org.uk

## South West
29 Queen Square
Bristol BS1 4ND
Tel: 0117 975 1308
Email: southwest@HistoricEngland.org.uk

## Swindon
The Engine House
Fire Fly Avenue
Swindon  SN2 2EH
Tel: 01793 445050
Email: swindon@HistoricEngland.org.uk

## West Midlands
The Axis
10 Holliday Street
Birmingham B1 1TG
Tel: 0121 625 6870
Email: westmidlands@HistoricEngland.org.uk

## Yorkshire
37 Tanner Row
York YO1 6WP
Tel: 01904 601948
Email: yorkshire@HistoricEngland.org.uk

# Historic England

We are the public body that looks after
England's historic environment. We champion
historic places, helping people understand,
value and care for them.

Please contact
guidance@HistoricEngland.org.uk
with any questions about this document.

HistoricEngland.org.uk

If you would like this document in a different
format, please contact our customer services
department on:

Tel: 0370 333 0607
Fax: 01793 414926
Textphone: 0800 015 0174
Email: customers@HistoricEngland.org.uk

HEAG119
Publication date: July 2016 © Historic England
Design: Historic England

Printed in Great Britain
by Amazon